AFRICAN ART
AS
PHILOSOPHY

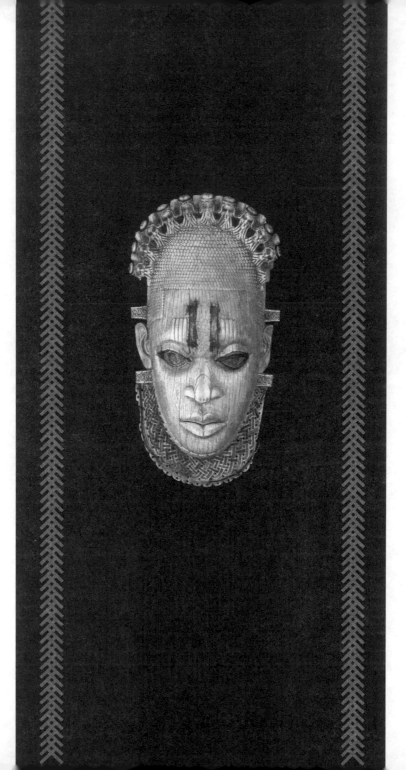

AFRICAN ART

AS

PHILOSOPHY

SENGHOR,
BERGSON,
AND THE IDEA OF
NEGRITUDE

Souleymane Bachir Diagne

Translated from the French by
CHIKE JEFFERS

OTHER PRESS

New York

Production editor: Yvonne E. Cárdenas
Text designer: Patrice Sheridan
This book was set in Galliard by
Alpha Design & Composition, Pittsfield, New Hampshire.

1 3 5 7 9 10 8 6 4 2

LIBRARY OF CONGRESS CATALOGING-IN-PUBLICATION DATA
Names: Diagne, Souleymane Bachir, author. | Jeffers, Chike, 1982- translator.
Title: African art as philosophy : Senghor, Bergson, and the idea of negritude / Souleymane Bachir Diagne ; translated from the French by Chike Jeffers.
Other titles: Léopold Sédar Senghor. English
Description: New York : Other Press, [2023] | Includes bibliographical references.
Identifiers: LCCN 2023006266 (print) | LCCN 2023006267 (ebook) | ISBN 9781635423211 (paperback) | ISBN 9781635423228 (ebook)
Subjects: LCSH: Senghor, Léopold Sédar, 1906-2001. | Senghor, Léopold Sédar, 1906-2001—Criticism and interpretation. | Negritude (Literary movement) | Art, African--Philosophy. | Philosophy, African. | Africans in literature. | Bergson, Henri, 1859-1941. | LCGFT: Literary criticism.
Classification: LCC PQ3989.S47 Z62213 2023 (print) | LCC PQ3989.S47 (ebook) | DDC 848/.91409—dc23/eng/20230508
LC record available at https://lccn.loc.gov/2023006266
LC ebook record available at https://lccn.loc.gov/2023006267

CONTENTS

INTRODUCTION
TO THE 2023 EDITION

ON 28 NOVEMBER 2017, having traveled to Burkina Faso, French President Emmanuel Macron gave a speech in which he expressed his will to rebuild the relations between France and Africa on new foundations. He had already spoken in the same sense on different occasions, acknowledging that the new partnership France wanted to build with Africans, with the continent's youth in particular, was impeded by France's history of colonialism, calling into question a relationship that needed repair. During his visit in Burkina Faso, before an audience of students at the University of Ouagadougou, Macron chose to focus on one aspect of the reparation of what he had himself called the colonial "crime against the human":

the spoliation, by violence, of African artefacts, taken from the continent to be stored in ethnographic museums in Europe. Recognizing that most classical African art was in European museums, he declared: "The African heritage cannot only be in private collections and European museums. African heritage must be promoted in Paris, but also in Dakar, Lagos and Cotonou, and this will be one of my priorities."

Senegalese academic Felwine Sarr and French academic Bénédicte Savoy were then tasked by Macron with the mission of preparing a report on the issue. They completed *The Restitution of African Cultural Heritage, Toward a New Relational Ethics* in 2018. Following the report and after the French parliament granted legal authority to the required operations, France has now given back to Senegal and Benin objects that were taken by its soldiers as spoils of war: a sword that belonged to Senegalese religious leader and resistant Shaykh Umar Tall (1794–1864), twenty-six objects that were taken from the palace of King Behanzin (1844–1906) of Abomey when it was sacked by the French army in 1892: royal seats, portable altars, sculptures...

To be sure, Macron's speech in Ouagadougou was followed by effective decisions and results, but it is necessary to recall that Africa had launched a struggle for its art in the late 1950s, a time when African nations were in the final stages of their march towards independence: the

restitution of their heritage was an important dimension of their struggle. That dimension is precisely the topic of Bénédicte Savoy's *Africa's Struggle for Its Art: History of a Postcolonial Defeat*, about the restitution of African art.[1]

Going through the different stages of the struggle, Savoy puts a particular emphasis on the years 1965 and 1966, when the president of Senegal, the poet and philosopher Léopold Sédar Senghor (1906–2001), was fully engaged in the preparation of the Premier Festival Mondial des Arts Nègres (First World Festival Negro Arts), which he considered to be the big event of his presidency. For him, having Dakar as the capital city of global Black arts for the duration of the festival was the true celebration of the independence of his and other African countries six years before. In this event, which brought together in Senegal more than two thousand writers, musicians and artists from continental and diasporic Africa to celebrate, Senghor saw the true meaning of the poetic, philosophical, and political movement called "Negritude," of which he was one of the pioneers: namely, the notion that Africa was not just the cradle of the human species, but also a force of continuous creation of humanity in the continent and its diasporas. To celebrate African art was to celebrate that creative force.

The *élan vital* of African art in the philosophy of Léopold Sédar Senghor is the topic of this book.

How to celebrate African creative force, African artistic élan vital, when the best of its manifestations are in museums in Europe? In 1965, as the festival was being planned, in the January issue of *Bingo*, Paulin Joachim (1931–2012), an African poet and journalist born in Dahomey (now Benin) but who was then based in Senegal, wrote a resounding editorial, the title of which was a response to that very question: "Give us back Negro art!"* In the words of P. Joachim: "There is a battle that we must valiantly fight on all fronts in Europe and America as soon as we have found a solution for the most urgent problems gnawing at us: the battle for the recovery of our art works which are scattered across the globe."[2]

One word summarizes the impact of the *Bingo* editorial: panic. Bénédicte Savoy, who describes the editorial as a "call to arms," writes that it had the effect of a "bomb" in European museum circles, at a time when they were eager to protect "the artistic productions of the Black world" in their possession from the consequences of decolonization. Thus, the transfer of the collection of the National Museum of African and Oceanian Arts in Paris from the Ministry of Colonies to the Ministry of

* The translator and I have chosen to keep the word "Negro" instead of "Black" because that was the choice made by the writers of the Negritude movement. It is the only choice consistent with the concept of "Negritude," which is now also an English word.

Culture was meant to shield it from any claim of restitution on the principle of the inalienability of national heritage. Likewise, in Belgium, the director of the Ministry of Culture had ascertained that in the discussions between his government and the new Republic of Congo, the latter's requests for restitution would simply be set aside. These are two examples that illustrate the defensive attitude of the museums of the North and explain the panic provoked by Joachim's pen.

The *Bingo* editorial could have had a major and probably crippling impact on the World Festival of Black Arts. The museums in France, Switzerland, the United Kingdom and the United States that had agreed to lend pieces of their African collections were certainly alarmed by Joachim's thunderous demand that "Negro art" be restituted and not just lent. It took much Senegalese diplomacy and firm commitments to put the question of restitution on the back burner for the loans to finally happen.

History would repeat itself eleven years later when Nigeria organized the Second World Black and African Festival of Arts and Culture, known as Festac 77.

The very logo of Festac, the famous ivory mask believed to date from the sixteenth century and representing Idia, the queen mother of the kingdom of Benin, became the eloquent symbol of British colonial plundering of African heritage. *Idia* is well known as one of the masterpieces of

Benin court art that were looted by British troops in 1897 and kept in a collection of the British Museum since 1910. Naturally, Festac organizers asked for a loan of the "Benin bronzes," and *Idia* in particular.

In an article published by the pan-African online magazine *Chimurenga* on 18 October 2021, under the title "Festac at 45: Idia Tales—Three Takes and a Mask," Dominique Malaquais and Cedric Vincent recount how Nigeria was turned down for the loan of this magnificent work of art by the British Museum.[3]

The refusal of the loan by the museum took the form of an offer to make a copy of the *Idia*—which was even made too late for the festival. The organizers of Festac 77 silently refused what can be described as the museum's poisoned gift by leaving its manufactured copy in its hands. But they did more and better by commissioning the creation of another *Idia* by Nigerian artists. When the work was presented to President Obasanjo, he commented that it manifested the creative power that the grandchildren of the great artists of Benin had inherited from their ancestors. In other words, African classical art is creative *élan vital*, and not the mechanical reproduction of reality or of another artefact. This is the core of the philosophy of African art shared by Léopold Sédar Senghor, Aimé Césaire (1913–2008), and Léon Gontran Damas (1912–1978), the founders of the Negritude movement.

It was the message delivered by Césaire at the First World Festival of Negro Arts in 1966 in his lecture, "On African Art." In this speech, the Martinican poet warned the artists of the continent against imitation. He declared:

> In Africa, art has never been technical know-how, because it has never been a copy of reality, a copy of the object, or a copy of what we call reality. That is true of the best of modern European art, but that has always been true of African art. In the African case, the point is for man to recompose nature according to a deeply felt and lived rhythm, in order to lay on it a value and a meaning, to animate the object, to vivify it and turn it into a symbol and a metalanguage.[4]

The message was clear: African art is not and should not be conformity to an external model, even be it African art, but must remain continuously power of creation.

To better understand the significance of the Nigerian response to the condescending offer of the British Museum, a rapprochement can be made with Walter Benjamin's reflection published in 1935 in "The Work of Art in the Age of Its Technical Reproducibility":[5] that the *aura* that a work of art exudes in its *hic et nunc* presence commands a religious relationship to its uniqueness. It is precisely this uniqueness that no longer exists when

photography and cinema reproduce again and again the object whose aura then inevitably declines.

To read the decision by Festac 77 organizers to recreate the *Idia* in the light of Césaire's lecture "On African Art" and Benjamin's "Work of Art in the Age of Its Technical Reproducibility" is to understand that their response to the British Museum's offer was not to simply say "keep your copy, we are going to manufacture one ourselves." What it meant was "what makes the work of art is the creative force that gives birth to it, and that matrix is continuously fertile."

First, the Nigerian *Idia* for the festival was not a copy but a recreation, and therefore not so much concerned with absolute fidelity to the object in the custody of the British Museum, the modern artists having moreover complemented certain aspects of it. Second, and as a consequence, it was now the "original" in the museum that had become a copy, because it has been made clear that the force that produced it had gone home, taking the aura with it. While the recreated *Idia* was a living object sustained by the creative power manifested by the artists of Benin, the *Idia* of the British Museum was now a dead copy in the glass walls that enclosed it like a coffin.

The message carried by the living *Idia* encapsulates Senghor's philosophy of African art, or, rather, his understanding of African art as philosophy of *élan vital* developed in this book.

[Y]ou speak of my ambiguity concerning Negritude. The case of ambiguity is similar to that of contradiction. At the beginning of the elaboration of a theory, in the abundance and over-abundance of youth, we always passionately pull together contradictory elements. We must wait until the age of maturity for these to become clear and symbiotically organized.

Léopold Sédar Senghor

(in a letter to Janet Vaillant, 6 October 1970)[6]

INTRODUCTION
The Initial Philosophical Intuition

I am convinced that art represents the highest task and the truly metaphysical activity of this life.

Friedrich Nietzsche[1]

HENRI BERGSON TEACHES us how to read philosophers: we must begin by taking a step back from their thought in order to return to its sources, weigh the influences that nurtured it and pinpoint the ideas of which the doctrine is a synthesis. But the real fruit of this effort, Bergson indicates, is reaped at the point where we discover the initial intuition of which the doctrine is an unfolding, the point at which we see its parts "fit into one another" and at which

"the whole is brought together into a single point." Here, the author of *L'Evolution créatrice* (1907)[2] tells us, we discover something "infinitely simple, so extraordinarily simple that the philosopher has never succeeded in saying it." From thesis to thesis, he has never stopped seeking to express this initial intuition.[3]

When we go back to its sources and weigh the influences to pinpoint the ideas of which it is a synthesis, the first thing we discover about Senghor's thought, his philosophy of Africanity, is that it is of course also the philosophies of the milieu in which he lived and thought, philosophies which Jacques Louis Hymans has discussed in what remains the best (i.e. most thorough) intellectual biography of the Senegalese poet to date.[4] Negritude, as Senghor christened his philosophy, is a product of Africa and its diaspora; it is a product of the movement of the Harlem Renaissance; it is also a product of Jean-Paul Sartre, of Henri Bergson, of Lucien Lévy-Brühl, of Karl Marx and Friedrich Engels, of Leo Frobenius, of Pablo Picasso, of Pierre Teilhard de Chardin and of others. It is, in short, the theoretical use of all available means.[5] Moreover, Senghor himself consistently maintains that what permitted the multifarious undertaking of bringing to light an *alternative* African thinking was the intellectual revolution marked by Bergson's first book, *Essai sur les données immédiates de la conscience* (1889),[6] which revealed an *alternative* way of seeing, a direction for

philosophy radically *alternative* to that which, until then, in order to save reason from the sophistry of the Eleatics, Aristotle had set for it.

But what is the initial intuition at the source of all these directions in which his thought flows? It is, in short, that there is a truth in African art which is itself a form of philosophy. Senghor is a Nietzschean philosopher: like the author of *Also sprach Zarathustra: Ein Buch für Alle und Keinen* (1883–85),[7] he declares (and it is the matrix for his thought) that we have art so that we may not die of truth. More precisely, he claims that we have the truth of African art, of what was called "Negro art," so that we may not die of a narrow and reductive rationalism. And, even before this, so that we may not die of the colonial negation. That this would be the starting point of Senghorian philosophy is normal when we think about it. For what, from the beginning of the twentieth century, among great artists and poets (and even racist thinkers like Joseph Arthur Comte de Gobineau), was recognized as an essential contribution by the black African world to world civilization? "Negro art." Thus it was natural that a colonial subject like Senghor, who from his youngest years (when he stood up to his teachers at the mission school), refused to accept that Africa was a cultural *tabula rasa*, would engage in his first reflections on Africanity based on art from the continent.[8]

Beyond affirming the aesthetic virtues revealed in pieces of art created by Africans, Senghor wished to stress the metaphysics they offered for reflection: along with the art through which it had been written, he wished to rescue a worldview, a feeling and a thinking that were also contributions to the humanism of tomorrow by African being-in-the-world (as Sartre, using the language of Martin Heidegger, called Negritude). Senghor's approach is often contrasted with that of Aimé Césaire. The latter would remain a poet throughout his relentless and constantly renewed proclamations of Negritude[9] while Senghor ventured (and went astray, according to those who criticize him in a harsh and radical way, without attention to detail) to find it an additional metaphysical expression. Senghor could not be satisfied with the "great Negro cry" of the poetic revolt. He needed to philosophize for the sake of expressing what lay behind African art. His critics, who generally spare Césaire, claim that he made more mistakes. If they are right, it is because he took the risk of metaphysics.

This initial intuition—that African art is a philosophy and a humanist one—Senghor never stopped expressing throughout his life in his theoretical texts, most times successfully, sometimes in ways that proved to go nowhere or with formulations that were at least awkward. Senghor attempted to express what philosophy one could read in

African plastic arts, songs and dances. It is within this primarily *hermeneutic attitude of deciphering* that the truth of his philosophy lies. Of Césaire's work, Patrick Chamoiseau and Raphael Confiant have written that the time is coming when we shall learn to read it "without wearing the glasses of Negritude."[10] This is true for Senghor as well: we must not take Negritude for granted and immediately confront the overly famous formulae in which we sum it up. Avoiding this guards us from criticizing too quickly, polemically and harshly the essentialism, the racialism, etc. We must begin by retrieving the initial attitude, the hermeneutic posture that Senghor adopted from his early writings onwards in order to answer the question (which, as we will see, was also Picasso's): What do African masks *mean*? What do these objects, labelled fetishes, *say* once the gods have departed from them? Taking this question as his point of departure, Senghor joyfully brought to light an ontology in which being is rhythm, an ontology which is at the foundation of traditional African religions. African arts, he demonstrated, constitute the language of this ontology. The second chapter of this book, "Rhythms," is dedicated to an exposition of Senghorian thought as a hermeneutic of African art.

The chapter that precedes it, "Exile," is a prelude. This first chapter returns to the meaning of the support provided by the existentialist philosopher, Sartre, with

his preface, "Orphée noir" ("Black Orpheus") to the *Anthologie de la nouvelle poésie nègre et malgache de langue française* (published by Senghor after the war in 1948), the manifesto for Negritude, the word and the movement created by Léopold Sédar Senghor, Aimé Césaire and Léon-Gontran Damas. It recalls the misunderstanding on which this preface rests. In brief, Sartre explains why Negritude must be greeted as an incredible force for liberation but equally as a poetic invention made of words of fire, bound to disappear in its own flames. No substance exists in reality behind the poetic incandescence in which, in the end, it exhausts itself. Senghor clearly thinks the complete opposite: that behind words there is being and before exile there is the kingdom. Once again, there is art: there are objects which are present before us, which express philosophical *content* for which an account must be given. After the anthology and "Black Orpheus," that Sartrean kiss of death, Senghor never stops exploring this content.

Art is a certain approach to reality, as scientific knowledge is another. From the theory of African art to the theory of knowledge, Senghor makes the transition that constitutes the aspect of his work that has caused the most controversy. In his "Attempt at a Self-Criticism" (1886), Nietzsche returned to the work of his youth, *Die Geburt der Tragödie* (1872) (the early explorations of the

relationship, which is at the core of his thought, between art and truth), to define "the task which this audacious book dared to tackle for the first time" in the following terms: "to look at science in the perspective of the artist, but at art in that of life."[11] It is, in a way, a similar audacity that animates the Senghorian enterprise of making an African *knowing*, an African comprehension of reality, out of African art. He finds justification for such audacity in the opinions of ethnologists but also, equally, in his reading of Bergson. The resulting approach is studied in the third chapter of the present work, "Co-naissance."

It is, once again, art that lies at the foundation of Senghor's political philosophy, explored in the fourth chapter of this book, "Convergence." Very often in the course of his life as a political figure, Senghor spoke (not without contempt) of the vanity of "political politics" in order to draw a contrast with true politics. Here, clearly, is a theme common to all politicians who invariably deny *doing* politics and claim to be moved only by Ideas. However, this theme also corresponds, for Senghor (in his writings), to his desire to think of the action of leading—especially for those to whom political responsibility is entrusted—as the organic continuation of a cosmology inspired by the philosophy of Teilhard de Chardin. Positive action for the poet-president (as he liked to be called), who chose as the title of the volumes collecting

his essential theoretical writings the simple word *Liberté*, is thus the choice to aid cosmological forces—or rather, to speak like Teilhard de Chardin, to follow cosmogenetic generative forces—of convergence towards a panhumanism. A politics that is not political would therefore be, for example, one based on the art of accommodating differences by means of dialogue for the purpose of a meeting of cultures. The panhumanism which is to be founded on the dialogue of civilizations is also the advent of a new man, who is, as with Nietzsche and the "young Marx" (who is, for Senghor, as we will see, the "true Marx"), an artist.

The point here, then, is to provide a reading that relates back to the initial intuition from which stem the arguments proposed and defended by Senghor throughout a life that even the responsibilities of Parliament after the Second World War and then as the head of state of Senegal (1960–80) did not prevent from being poetically and intellectually productive. From one of his earliest writings, "Ce que l'homme noir apporte" (1939),[12] until one of his last, *Ce que je crois: négritude, francite, et civilisation de l'universel* (1988),[13] this intuition that "Negro art" *is* philosophy remains at the core of his thought. The following pages will analyze the unfolding of this intuition in different directions, restricting the focus to Senghor's theoretical writings. I am aware, of course, that he himself said that if only a part of his poetic, political and philosophical

work could remain, he would like for it to be his poetry alone. It is also true, no doubt, that we can read his poetry as an expression of his philosophical thought; many do. Still, I did not want to appeal to his poetry when unlike, for example, another Third World poet/philosopher/statesman to whom he has been compared, the Indian Muhammad Iqbal, he did not write truly philosophical poems. I have consequently kept more or less strictly to those prose writings in which we read in total clarity the dialogue maintained by Senghor with the principal authors who helped him to think through the developments and implications of his original intuition.

The chapter titled "Mixture" concludes the book with the question of Senghorian essentialism and thus also the relevance of his thought to a time like ours, which is generally anti-essentialist as it is dominated by what is called postcolonial thought. This final chapter revisits the importance for the author of *Négritude et Civilisation de l'universel* (1977)[14] of *métissage* ("mixture" or "miscegenation"). It is indeed important to remember that the concept, when we recognize its true place and weight in his reflections, forbids thinking of Senghor's philosophy as a simple metaphysics of essences fixed in their separation, as it is often caricatured in order to make it the classic example of the discourse which our postcolonial situation would deconstruct. This chapter returns to a recurrent

point in the book, namely, that underneath what we may call Senghor's "strategic essentialism"[15] the discourse of hybridity is always at work, rendering fluid the identities on display. This is, at base, another effect of art. It will be noted that each of the titles of the book's chapters are keywords in Senghor's thought: rhythms, *co-naissance* (a way to write the French term for "knowledge" that Senghor adopts from Paul Claudel to express the notion of a knowing [*connaître*] that consists in being born to and with [*naître à et avec*] that which is known), convergence, mixture; though, rather than "exile," it is "kingdom" that is the Senghorian keyword. It is rather Sartre who speaks here to say that Negritude is exile, whereas the entire Senghorian project will be to proclaim it a kingdom.

EXILE

I do not only place this Kingdom at the
beginning of my life. I also place it at the
end. In general, I would say that the ulti-
mate goal of man's activities is to recreate
the Kingdom of Childhood.

Léopold Sédar Senghor[1]

Language alone will inform me of what I
am...

Jean-Paul Sartre[2]

IN JUNE 1949, Gabriel d'Arboussier's article
"Une dangereuse mystification: la théorie de la
négritude" appeared in *La Nouvelle Critique*, a
journal of the French Communist Party. In the
spirit of the saying "Platonists are my friends, but
more so is the truth," the author, then one of
the leaders of the Rassemblement Démocratique
Africain (African Democratic Rally), concludes

his article with these words: "...whatever our ties of friendship may be—and I would even say because of these ties—we will not cease to pursue our work of clarification and of unmasking all the false prophets of existentialism, which is reactionary and a camouflaged but resolute adversary of any revolution, whether it is black or white."[3]

This conclusion gives a good indication of the article's content: it is a critique, or rather a radical denunciation, of a thought presented as fundamentally reactionary, resolutely counterrevolutionary and all the more dangerous because it hides itself under the noble and progressive cloak of a struggle for the emancipation of oppressed black peoples. This article expresses the Communist Party's line on the *Anthologie de la nouvelle poésie nègre et malgache de langue française* that Senghor had just published, and on "Black Orpheus," Sartre's preface.[4] According to d'Arboussier, the poet Senghor (he had, by then, published his *Chants d'ombre* [1945; Shadow Songs], *Hosties noires* [1948; Black Hosts] and *Ethiopiques* [1956]),[5] the philosopher Sartre and the journal/ publishing company Présence Africaine[6] (which, along with its editor-in-chief Alioune Diop, is tied to the Negritude movement) all participate in a "mystification" that aims to distract people from the real struggle and the real stakes. To be opposed on an ideological basis to an anthology of poetry is *a priori* absurd, unless the idea is to single out the preface and assert that it provides

the "meta-poetic" meaning and substance of the choice to collect the poems, thus making it the focal point of the critique. This is exactly what d'Arboussier, whose denunciation rests on two main points, does.

His first point is that "Black Orpheus" is much more than a preface to a poetic anthology. In fact, he presents it as exactly what, at its deepest level, it truly is: a chapter of existentialist philosophy "applied" to the "black question" as it can be to the "Jew" or the "second sex." Thus, while one of d'Arboussier's points of attack is that authentic "revolutionary poets" were not selected, this claim turns out to be quite marginal in his critique; the poets he has in mind do not have the stature of those in the anthology, and those in the anthology are not the conservatives and counterrevolutionaries the claim implies they are. In reality, the attack is aimed at existentialism itself insofar as, through "Black Orpheus" and through Negritude as its poetic incarnation, it appears to be engaged in the enterprise of introducing the lure and confusion of race into the realm of the struggle against capitalist and imperialist domination.

The second point of attack, which is related to the first, consists in claiming that this must be understood as a messy and untimely insurrection of particularism when the issue at hand is rather the universality of class struggle as the driving force of history. This racial enterprise is

a theoretical mystification because it claims to be something more than what it is: an accident of the Subject which bears universality, i.e. the proletariat. What is meant by "accident" is that when the oppressed *happen to be black*, this contingent fact provides no material for existentialist theory because the liberating thought which covers them is already present in Marxism (and its Soviet incarnation). This enterprise is a practical mystification because it creates the objective conditions for a division and diversion of the energy for liberation.[7] Let us consider d'Arboussier's points of criticism which constitute the matrix for most of the criticism of Senghor's philosophy that will follow.

WHEN, IN 1948, Birago Diop and Senghor ask Sartre to offer the prestige of a preface written by him to what will become, because of its nature but also by means of this preface, a poetico-political manifesto for Negritude, it has been five years since the publication of his grand philosophical treatise on existentialism, *L' Être et le néant*: *Essai d'ontologie phénoménologique* (1943). We are immediately free, he tells us: freedom is not free to not be free, not free to not exist. As a result, no given situation can take away my freedom, for it is always my freedom that decides the meaning that this situation has for me. A rock does not present

me with adversity, Sartre says, until I have formed the *project* of scaling it rather than going around it. It is nevertheless true and must be noted that "the Other's existence brings a factual limit to my freedom."[8] With this Other, in particular, there appears the notion that the race to which I belong is also part of the situation in which the Other holds me prisoner with his look.

> This is because of the fact that by means of the upsurge of the Other there appear certain determinations which I *am* without having chosen them. Here I am—Jew or Aryan, handsome or ugly, one-armed, etc. All this I am *for the Other* with no hope of apprehending this meaning I have *outside* and, still more important, with no hope of changing it.[9]

With the discovery of my race, which I learn that I belong to,

> in and through the relations I enter into with others...I suddenly encounter the total alienation of my person: I am something which I have not chosen to be. What is going to be the result of this situation?[10]

Sartre thus philosophically encountered the question of race when his views on the "situation"—that it is always

up to me to constitute and go beyond with my project—
seemed to run into a stumbling block. What does my
project become in relation to racial determinations? Well,
Sartre claims, even these elements of my situation only ap-
pear with a meaning that my freedom has conferred upon
them. It is true that they exist in the eyes of the Other
that takes me for an object and who thus manifests "a
transcendence that transcends me," as Sartre describes the
face-to-face situation.[11] They cannot, however, change the
fact that I am still a *being-free-for.* So, for example, a Jew is
not first a Jew who can then be ashamed or proud; it is his
pride, his shame or his indifference towards being a Jew
that reveals for him his being-a-Jew, and this being-a-Jew
only exists by means of his freedom to adopt it.

When he writes "Black Orpheus," then, it is under-
standable that Sartre pursues the same line of analysis in
relation to what it means to be black in the face of a racist
world and that he continues to read, in all these black poets
who proclaim both revolt against alienation and affirma-
tion of self, his own existential analysis. We may note that,
in the history of Western thought, when a philosopher has
managed to bring up race (the race of others, of course), it
has always been from the outside and often to say horrible
things unworthy of a "principal soul," to use Michel de
Montaigne's phrase. Since his analysis is existential and since
it is registered in terms of the situation–project conceptual

couple, Sartre speaks of race from the inside, asking: What does my freedom mean when I am of an "other" race? This is the question he asks in "Black Orpheus."

Prefaces by Sartre, as we know, are never simple invitations to discover the work they introduce. On the contrary, when they take hold of a work it is for the purpose of stretching out and laying upon it (to take one of Sartre's own images) and appropriating it in order to speak its ultimate truth, that which totally defines it (even if it is not aware of it). We can compare "Black Orpheus," from this perspective, to *Saint Genet, comédien et martyr* (1952),[12] the book-length preface in which Sartre introduced what was then the complete works of Jean Genet. Edmund White calls this work by Sartre an "existential psychoanalysis" of the writer,[13] and recalls Genet's reaction to Sartre having thus "stretched out and laid" upon him: "I am the illustration of his theories concerning freedom," said Genet about the book Sartre dedicated to him. He also told Jean Cocteau: "You and Sartre have made me into a monument. I am somebody else, and this somebody else must find something to say."[14] The same thing, more or less, will happen to Senghor; he will have to find "something to say" after "Black Orpheus." Sartre will plaster a kiss of death on Senghor's anthology of black poets (a manifesto for Negritude, which Sartre christens "Eurydice") just as he did on Genet's work.

In the beginning is exile, according to Sartre, and this is the experience of which Negritude is the daughter. Whether one is from the diaspora like Césaire, or from a Serer village like Senghor, one does not have a home when one is black. One lives in ontological exile, exiled in one's very being, for one lives in a world where—for "three thousand years," Sartre claims, Being is white and speaks white. The Kingdom of Childhood that Senghor *remembers* or the Africa that the poets of the diaspora *imagine* are not different places but the same poetic topos, the same nostalgic fabrication of an abode by someone whose experience, with the coming to consciousness of their situation, is of always being homeless, outside of one's self, outside of being, outside of language. When these black poets meet one another in the anthology, it is not a matter of a continental Africanity welcoming home her children who had left but, rather, the attempt to overcome a primordial dispersion of all into the darkness outside Being.

What facilitates the overcoming of this diasporization is the poetic use of language, which is the only thing that can accomplish the reorientation of Being. For this reorientation to take place, it is imperative that this language be the one which Being itself is said to inhabit. The Irish, Sartre claims, assert themselves in the face of oppression and alienation by reclaiming the Irish language. Africanity, because it is exiled from itself and dispersed, will constitute

itself as francophone and thus demand to be received by the language which naturally speaks universality. This encounter between Africanity and the French language will manifest itself as impossibility and will take place by means of the very fact of its impossibility. What the anthology's poets measure when they sing their songs in French is the gap that the language opens up underneath and between their words, thus undoing the usual links that hold them together, domesticated. Black poetry will take place in the impossibility of *syntax,* and thus in the form of *parataxis,* making each image an isolate, rendering each word monadic, "total" and "foreign to the language," to speak like Stephané Mallarmé. Sartre brings up Mallarmé as well as Georges Bataille because they, more than anyone and with more accuracy and precision, have articulated the fact that Being slips away in the language which seeks to express it, and that it is by "upping the stakes of verbal impotence, in rendering words mad" that "the poet makes us suspect the presence of Being... beyond the clamor which cancels itself by itself...."[15] It is thus the distance, the *gap*, which creates poetry, that is to say, which silently points to Being, and it is this which has been sought ("from Mallarmé to the Surrealists") in the enterprise of calling language into question.[16]

That Being is the great concern of poetry is precisely what the poets of Africanity are *well displaced* to know.

The will to destroy oppression and alienation for them will also be, quite naturally, the will to squeeze out of language its weight of exclusion; this will be translated into the art of "smash[ing]" words, "break[ing] their customary associations" and "coupl[ing] them by force."[17] When black poets embrace French, it is also to destroy it, Sartre claims, and that is well and good for they thus meet with and fulfill "the profound aim of French poetry...this auto-destruction of language."[18] This is why those that Senghor calls natural masters of parataxis are, for Sartre, those who have completed this poetic project and fully accomplished in our time what Surrealism foreshadowed. André Breton's recognition of Césaire's *Cahier d'un retour au pays natal* (1947)[19] is thus not a matter of a recognition of paternity but, rather, an amazed recognition of what is really at stake behind Surrealist wordplay, here in plain sight. As Sartre writes: "[Black] poetry in the French language is, in our times, the sole great revolutionary poetry."[20]

This is a kiss of death. "Black Orpheus" is characterized from the beginning by a violence in tone that is a trademark of Sartrean prose, employed here to salute the rising of black people against oppression, racism and negation, and to say (in a uniquely poetic manner) that Negritude—a remarkable idol born only in the song of the poets, just as Eurydice is snatched out of nothingness by the evocative power of Orpheus—is bound to disappear.

For, in reality, Africanity never existed outside its evocation. Encapsulated entirely in the poetic utterance, it is destined, from the beginning, to vanish in the vibration of the words out of which it is made. This amounts, in the end, to claiming once again that black peoples have never really been actors or factors in history, even while they revolt. Sartre decrees that Negritude, because it is the negation of the most radical negation, has produced the only authentically revolutionary poetry of our time and has brought the revolt of Surrealism to the point of incandescence. The fact remains, though, that the "anti-racist racism" that it represents (Negritude will subsequently have to work to extricate itself from this Sartrean phrase) is simply a poetic aspect of the real actor, the real "people," i.e. the proletariat. Sartre takes away from the proletariat their poetic capacity to transfigure the world in order to give it to black people, but he leaves to the proletariat the capacity to actually transform the world. The Negritude that he makes into a moment in a dialectic which will see racial differences reabsorbed into the universal is not even a true "moment": it is more, we should say, a moment in a moment. D'Arboussier's critique of "Black Orpheus" is ultimately unjust even from his own point of view because it does not pay enough attention to the dialectical disappearing act that Sartre's preface *likewise* performs on Negritude.

What effect does it have on an identity claimed in the face of its negation to know itself as thus bound to disappear? Frantz Fanon says it better than anyone:

> When I read that page [of "Black Orpheus"], I felt that I had been robbed of my last chance. I said to my friends, "The generation of the younger black poets has just suffered [an unforgiving blow]." Help had been sought from a friend of the colored peoples, and that friend had found no better response than to point out the relativity of what they were doing...Jean-Paul Sartre, in this work, has destroyed black zeal.[21]

The poets of Negritude will go on to reject the Sartrean verdict, with its consequence that their child is stillborn, in different ways. This is the frame in which we can read Césaire's "Lettre à Maurice Thorez" (1956), in which he makes his resignation from the French Communist Party not only a protest of the Party's alignment with the Soviet Union but also an affirmation of the reality of a particularity whose fate is not to be dissolved in universality but, rather, to recognize itself in it, in all senses of the term. Césaire begins with the grievances one can have against a party that has not managed to assert its independence from Russia before arriving at what he

describes as "considerations related to [his] position as a person of color."[22] These considerations involve the exaltation of singularity: the singularity of a "situation in the world that cannot be confused with any other...of problems that cannot be reduced to any other problem...[and] of a history constructed out of terrible misadventures that belong to no other."[23] He goes on to evoke "black peoples" in the plural and the need for them to have their own organizations which are "made by them, made for them and adapted to ends that they alone can determine."[24] Césaire insists that Stalinist "fraternalism," with its notions of the "advanced people" who must help "backward peoples," says nothing different than "colonialist paternalism."

Ultimately, what Césaire seeks (behind sometimes slightly hollow formulations such as "it should be Marxism and communism at the service of black peoples, not black peoples at the service of the doctrine") is to define the notion of a people by means of culture rather than politics. When he speaks of "the African variety of communism," just as Senghor will insist on an African socialism born of a "Negro African rereading of Marx," it is more a matter of culture than political doctrine. However, if there is unity beyond plurality (and Césaire exclaims: "Look at the great breath of unity passing over all black countries!"),[25] then this unity is in a movement more so than in a given essence. To proclaim this movement a cultural one is not

to oppose it to politics or to the people as proletariat: it is, rather, to say that its significance is wider and deeper than politics which it surpasses and includes. For Césaire, then, the constitution of a people is a matter of an existential response to an existential problem. He explains this again in a lecture given in Miami, in 1987, and reminds us that Negritude is a problematic word for a problematic situation and that it is definitely "difficult to use and handle":

> Negritude, in my eyes, is not a philosophy. Negritude is not a metaphysics. Negritude is not a pretentious conception of the universe. It is a way of living history within history: the history of a community whose experience appears to be...unique, with its deportation of populations, its transfer of people from one continent to another, its distant memories of old beliefs, its fragments of murdered cultures. How can we not believe that all this, which has its own coherence, constitutes a heritage?[26]

Of the trio Damas, Césaire and Senghor, it has been said that the last is more of a "theoretician" than his companions—that he takes up for himself the construction of exactly those things which Césaire does not want Negritude to be: a metaphysics or a conception of the universe. For Senghor, there exists an Africanity as real

as the material objects it has produced, which are, before all else, its works of art. These objects speak a language to be deciphered and they manifest an ontology that is consubstantial with the ontology of traditional religions. Senghor claims to have *experienced* this language, this ontology and the traditional religion of his Serer homeland and, in his poetry, he speaks of it as the "Kingdom of Childhood." This is not simply a poetic topos with no reality beyond that of a nostalgic evocation, from exile, of home as a mythic elsewhere. This kingdom is, one could say, a Platonic Idea, more real than reality itself and which reveals itself in certain encounters. For Senghor, Africanity is thus necessarily something more than a figure of dialectic—the negation of negation—a simple moment bound to disappear in the next synthesis.

When we take a closer look, we see that most of what Sartre writes in "Black Orpheus" is about Césaire, evident even in his choice of quotations from the poems in the anthology.[27] His central idea that Negritude is, first and foremost, "subjective," that it is a descent into the self, is principally aimed at capturing the truth of Césairean verse. On the side of the "objective" reality of Negritude are the poets of "the Continent" who want to express "the customs, the arts, the songs and the dances of the African populations."[28] Among them, we must single out Senegalese Birago Diop, of whom Sartre writes that his

poetry "alone is *at rest* because it comes directly out of the stories of *griots* and oral tradition."[29]

Sartre's statement of the true significance of what unites the poets of the anthology is hardly valid for Diop, and Sartre himself recognizes this when he evokes the exceptionality of the Senegalese poet/storyteller's poetry "at rest." We can understand this as implying that Diop is not engaged in trying to fill in the insurmountable *gap* that constitutes the shared experience of those who sing their Negritude in French. In that case, however, what are we to make of this exception? Is it a confirmation of the rule? Is it a sign that Diop should not have been in the anthology in the first place? Is he not enough of a poet? Or perhaps a poet in a way too different from Césaire? It is true that, in the case of Diop alone, Senghor chooses a folktale ("Les mamelles" ["Teats"]) along with two poems to include in the anthology. To justify the presence of the former, Senghor explains the nature of Diop's art in an introductory note. Certainly, writes Senghor, "Birago Diop is known primarily as a storyteller. But in Black Africa, the difference between prose and poetry is primarily technical, and what a thin difference it is!"[30] Later, in the same note, Senghor adds:

Birago Diop tells us modestly that he does not create anything new but rather contents himself with translating into French, tales heard from the *griot* of his

house: Amadou, son of Koumba. Do not be taken in. He does the same thing all our good storytellers do: using an old theme, he composes a new poem. The careless reader easily believes this is a translation, given how well the storyteller, who combines French finesse and robust Wolof simplicity, is able to render the life of the Negro African folktale with its philosophy, imagery, and unique rhythm.[31]

Later, in 1958, when he writes the preface to Diop's *Les nouveaux contes d'Amadou Koumba*, Senghor will revisit in greater detail the "translation" accomplished by the storyteller/poet who claims to give his francophone voice to Amadou, son of Koumba. The folktales recreated by Diop are, for Senghor, the expression of an ontology in which beings are forces susceptible to increase or decrease, i.e. forces that can be "rein-forced" or, alternatively, "de-forced," according to his neologism.[32] Moreover, the tales are dominated by a rhythm omnipresent in their dialogues and narrative structure, featuring, quite often, "the periodic return of the song-poem" to underline dramatic progression. Finally, and this point is important to explaining how Diop is an exception to Sartre's thesis, "with sovereign ease, [he] mixes text and translation, knocking together *Wolof* and *French*. Better yet, he draws gripping effects from simple translation."[33]

Here, then, is the explanation: Diop's aesthetic depends not on a gap but on a knocking together. In other words, his poetry gives the appearance of being "at rest" because it is constructed between the two languages—Wolof and French—with which it plays.[34] Without being able to really put his finger on it, Sartre could feel that the poetic value of Diop's work in French consisted partly in the presence, underneath it, of something else (another language, another voice, an old art of expressing), a *je ne sais quoi* which is no less real for being so and which makes his song into an evocation of a Eurydice that is not just a ghost bound to disappear.

Senghor recognizes this aesthetic of the in-between as equally his own. We have to take him at his word when he says that he threw his first poems into the fire after discovering, through coming back into contact with the athletic songs of his Serer culture, the poetic power of African art: he found himself to be a simple fabricator of verses rather than a poet and understood that he needed to recreate himself through that force. To play with the fire of both what he calls, in relation to Diop, the fabulatory power of this art and the French language: this is what the poetic path will be for Senghor. It is not just about producing a poetry of exile and of the impossibility of making what is absent be; it is about affirming that, in exile, the Kingdom of Childhood remains present as a continually creative

matrix that invites the poet to "rein-force" himself with its power of expression.

"Black Orpheus" is a peculiar and paradoxical preface. It accomplishes what the founders and promoters of the Negritude movement could have hoped for as the best possible outcome: that a friendly voice that carries well would make the *Anthologie* into the manifesto of a protest aimed at shaking up "the world's foundations." One can indeed count on the incomparably combative style of Sartre to do this. Yet, at the same time, "Black Orpheus" accomplishes the most radical critique and the most thorough deconstruction of that which it heralds. Sartre claims that the Africa which the poets of the anthology make into the heart of their song is "imaginary," invented. He indicates that the enterprise itself of announcing "the sum total of the cultural values of the black world" is, ultimately, an "anti-racist racism," a negation of negation that could never be authentic affirmation. As for its final end, there is scarcely any: in the final analysis, this protest does nothing but act magically through the poetic transmutation of words, those "miraculous arms" which could never replace the criticism of arms. It is therefore natural that the protest expressed by these self-appointed spokespersons would eventually be but a moment fated to dissipate in the sunlight of the real struggles for liberation led by the only true actor with history on its side: the proletariat.

No subsequent critique of Negritude or diatribe attacking Senghor's thought will ultimately say anything more than what Sartre has in this preface. That its Africa is the invention of a nativist discourse, that its idea of African philosophy amounts to an essentialist racialism employing a process of inversion (from the whiteness of Being to the Negritude of Being, from reason to emotion, etc.), all this can be read clearly enough in "Black Orpheus." We can even find there the critique that Senghor himself and his thought are so very *French* (made often by anglophone African intellectuals and all those who reproach Senghor for his commitment to and historic role in the construction of the Francophonie).

Senghor's thought will thus also be written against what "Black Orpheus" says about Negritude, and, first of all, against the claim that it is racism. Even when anti-racist, racism is totally repugnant to one whose philosophy is nourished, as we will see, by the views of Teilhard de Chardin and who declares himself to be oriented towards the construction of a "humanism of the twentieth century" and what he called, in the spirit of the Jesuit father, "the civilization of the universal." Senghor and Césaire confess that, during the beginning of the movement they founded with Damas, there was some temptation and tendency towards racism in reaction to the racism by which they had been victimized. Nevertheless, Senghor tells us, the spectacle of murder and destruction provoked by Nazi barbarism quickly convinced

the prisoner of war that Senghor became for two years (beginning in 1940), if he needed any convincing, that racism was an absolute evil that could only be defeated by an anti-racism that affirms, through and through, what Jacques Maritain calls "integral humanism."[35]

Senghor also writes against the idea of an impending disappearance of a Negritude made completely out of poetry and behind which there is no real being. Behind Negritude is the reality of an art and the fabulatory power that it represents. In the note on Diop in the anthology, Senghor somewhat elliptically indicates that the folktale constitutes poetry because of its "contempt" for reality and its "vision of the surreality beyond appearances" by means of which it "allows us to grasp the meaning of the profound life of the world."[36] In fact, by thus evoking the distortion of reality through which Diop's art opens us up to the profound life of the world, Senghor brings to mind what he wrote a few years ago regarding African sculpture in "What the Black Man Contributes." Revealing this contribution and thus fully understanding what the forms sculpted by the black man give witness to (whether he is an artist in stone, wood, bronze or words) involves, contrary to Sartre, researching a real world which exists, not poetically inventing one. This is the path Senghor invites us to take in order to enter into a universe woven out of rhythms, a universe he identifies as that which is revealed by the vision of the African artist.

RHYTHMS

Danced the forces that were given rhythm
by, that gave rhythm to the Force of forces:
Justice in accord, which is Beauty Bounty
Léopold Sédar Senghor[1]

FROM THE TROCADÉRO
TO THE IMAGINARY MUSEUM

NEAR THE END of 1906, at the time of
Senghor's birth, Picasso is 25 years old. He is al-
ready famous and numerous are the admirers of
his paintings, drawings and sculptures. What is
known as his "Blue Period" (1901–04) has been
succeeded by the "Rose Period" (1904–06)
with its harlequins and acrobats. Max Jacob, his
friend, poet and art critic, perceives the depth of
his genius. Guillaume Apollinaire, also a friend,
has dedicated an article to him in 1905 entitled
"Picasso: peintre et dessinateur,"[2] in which he
celebrates Picasso's present and future glory. It

even seems as if his life of bohemia and poverty must be coming to an end as connoisseurs, rich ones at that, begin to put the proper price on unsurpassable greatness: visiting his studio the year before, the Americans Leo and Gertrude Stein spent 800 francs for some paintings they took away; while that year, 1906, the art merchant Ambroise Vollard would pay 2,000 gold francs at one time to acquire several canvases. Ms. Stein would see her portrait, begun in 1905, completed. *The Portrait of Gertrude Stein* says something very important. But what?

Picasso, continually dissatisfied with the face, ended up erasing it and putting in its place a head for all eternity: the forehead is smooth and wide, the lines are "impersonal, schematic and regular";[3] rather than a head, it is a mask that looks off towards its own unfathomable mystery. Picasso's *Self-Portrait*, once again from the miraculous year 1906, gives the artist himself the head of a mask as well. The features are harsh, the shape pure, evoking a sculpture. "Picasso painted his own face as if it were a mask," write Marie-Laure Bernadac and Paule du Bouchet, "almost as if it belonged to someone other than himself. The intensity, the almost savage archaism of this self-portrait shows the progression Picasso had made over the course of several years, even over the previous few months."[4] But progression towards what?

Towards faces that transform themselves into masks? It is true that Picasso has a rich collection of masks and

other small sculptures. We know, for example, that among the "primitive" art objects he possesses is a magnificent Grebo mask made of wood and vegetable fibers, and full of geometrical lines: two cylindrical protuberances for the eyes, a rectangular one for the mouth, a triangle for the nose...It would be surprising indeed if nothing from these "fetishes" surreptitiously crept into his art! But for him to really look at these things, and for their "magic" to function, it would be necessary for them to acquire a new and stronger salience that will force him to *see* them. This turns out to be his visit in July of 1907, to the museum at the Place du Trocadéro in Paris.

Ethnographic museums are a negation of art because they prevent the objects on display from really looking at us. Because ethnography is constituted, at its colonial origins, as a science of what is radically other, it is in its nature to fabricate strangeness, otherness, separateness. An object in an ethnographic museum is kept at a distance, prevented from touching us because it is petrified: it cannot accomplish the movement André Malraux calls its "metamorphosis." This movement involves becoming a "work of art separated from its function." "The deepest metamorphosis," writes Malraux, "began when art no longer had any end other than itself."[5] The ethnographic museum claims to maintain the dimension of the religious function, but it is no more than a claim because the object has been irreparably cut off from this function and the

gods have withdrawn from it. Prevented, as regards its aesthetic face, from becoming a work of art, this object—created to make the divine present—finds itself equally missing its other face which looked to the god. Thus here it is exposed as a cadaver, doubly abandoned.

"The Trocadéro museum is in urgent need of reform," wrote Apollinaire, who deplored the fact that beauty found itself buried in a place given over to "ethnic curiosity" that attracted few visitors, instead of being offered up to "aesthetic sensibility." He explained that "[o]bjects of a principally artistic nature should be separated from...ethnography and placed in another museum." In fact, for Apollinaire, it is "the Louvre [that] should be collecting certain exotic masterpieces whose appearance is no less moving than those of the beautiful specimens of Western statuary."[6] Because Picasso, like his friend Apollinaire, is a poet able to see past the ethnographic fence, he understood during his visit to the Trocadéro how to look at objects in a way that gives life to things and unleashes the force of the spell. He later opened up to Malraux about what happened to him, who reported his words in *La Tête d'obsidienne* (1974)[7] and in the foreword he wrote in August 1974 for *Masterpieces of Primitive Art* (1982).[8] Here is the humorous account Picasso gave Malraux of his first visit to the Trocadéro (in 1937, "at the time he was finishing *Guernica*"):

Everybody always talks about the influence that the Negroes had on me. What can I do? We all of us loved fetishes. Van Gogh once said, "Japanese art—we all had that in common." For us it's the Negroes. Their forms had no more influence on me than they had on Matisse. Or on Derain. But for them the masks were just like any other pieces of sculpture. When Matisse showed me his first Negro head, he talked to me about Egyptian art.

When I went to the old Trocadéro, it was disgusting. The flea market. The smell. I was alone. I wanted to get away. But I didn't leave. I stayed. I stayed. I understood that it was very important: something happening to me, right?

The masks weren't just like any other pieces of sculpture. Not at all. They were magic things. But why weren't the Egyptian pieces or the Chaldeans? We hadn't realized it. Those were primitive, not magic things. The Negro pieces, they were *intercesseurs*, mediators, ever since then I've known the word in French. They were against everything—against unknown, threatening spirits...I too believe that everything is unknown, that everything is an enemy! Everything! Not the details—women, children, animals, tobacco, playing—but the whole of it! I understood what the Negroes used their

sculpture for. Why sculpt like that and not some
other way? After all, they weren't Cubists! Since
Cubism didn't exist. It was clear that some guys
had invented the models, and others had imitated
them, right? Isn't that what we call tradition? But
all the fetishes were used for the same thing. They
were weapons. To help people avoid coming under
the influence of spirits again, to help them be-
come independent. They're tools. If we give spirits
a form, we become independent. Spirits, the un-
conscious (people still weren't talking about that
very much), emotion—they're all the same thing.
I understood why I was a painter... *Les Demoiselles
d'Avignon* must have come to me that very day, but
not at all because of the forms; because it was my
first exorcism-painting—yes absolutely! It is for that
reason that later I also did paintings as before, like
Olga's Portrait: portraits! One is not a sorcerer all
day long! How would one live?[9]

"Why?" Picasso asks. His question has an answer
which is at once lazy, Eurocentric and paternalistic, and
which is contained entirely in the expression "primitive
art": since African art is a manifestation of primitive art
or, in other words, art in its infancy, it is natural that
they paint or sculpt "like that," the only way in which

humanity in its infancy is able to paint or sculpt. This art is "primary" in that sense. There is, however, another answer according to which there is nothing childish here; this answer begins by paying attention to the fact that Picasso asked, "Why sculpt *like that* and *not some other way?*" He sought to understand how it is that to sculpt *like that* gives form to the spirits, makes the unconscious speak or provokes a strange emotion.

We may note that "emotion" is also the word used by Apollinaire when he writes that the "result" produced by this art is a "powerful reality." It is precisely the riddle of this reinforced reality, perceived by the artist as unable to be domesticated simply by making it a *curiosity*, that Picasso's question aims to unlock. At the end of his foreword to *Masterpieces of Primitive Art*, Malraux speaks of the savage artist's "will to create"[10] (which we call "magical" only because of laziness) that ensures "their sculptures the enigmatic unity that connects their work, even when it borders on random expression."[11] Celebrating the entrance of savage sculptures into the museum from which they had been kept away, he concludes that "this crucial and ageless art, so strangely relevant to our own, is the art of our next investigation: the night side of man."[12] Apollinaire, Picasso, Malraux and others as well agree: behind the African masks and sculptures that now come to take part in the conversation of works of art gathered at

the heart of "the immense range of invented forms," as Malraux defines the "Imaginary Museum," we find the riddle of a way of seeing, thinking and feeling of which these objects are the writing.

Senghor's Negritude will claim to decipher this riddle and thus its most natural content will be answers to the questions posed by African art. To show that "African art forms, generally regarded as 'aesthetic' ... are equally interpretable as philosophical observations about the nature of the world" will be a major aspect of the Senghorian project.[13] Far from being reducible to the expression of an existential attitude without real content, this project is, in Senghor's mind, the expression of African philosophy itself, that is to say, the way of seeing, thinking and feeling that integrates fields of human activity as different as medicine, law, religion, logic and wisdom by serving as their *raison d'être* and the key to truly understanding them. Among these fields, artistic activity is primary, even before religion: because, where orality reigns, art constitutes the writing which allows us to read the metaphysics it transcribes.[14] Art is the evidence of African philosophy and, conversely, we do not attain full comprehension of African art without understanding the metaphysics from which it proceeds. This metaphysics, to present it in a word, is a metaphysics of *rhythm* which, according to Senghor, is at the core of African thought and experience.

READING AFRICAN SCULPTURE

Beginning in "What the Black Man Contributes," Senghor speaks of a *rhythmic* attitude, emphasizing the word and asking us to "[r]emember this phrase."[15] (He will consistently return to it over the course of many texts.) When he writes, in a formulation that will appear in different forms as a leitmotif of his thought, that "[t]his ordering force that constitutes Negro style is rhythm,"[16] he indicates in a footnote that this assertion is also defended in Paul Guillaume and Thomas Munro's *Primitive Negro Sculpture* (1926).[17] This is more than a passing reference: when we look closely at the referenced work, we discover how attentively Senghor read it and, above all, how much his philosophy of art remains, following this reading, a continued reflection on (and of) this book. It is, for this reason, necessary to discuss it here.

The French version of *Primitive Negro Sculpture* is composed of three parts.[18] First, a section in which the authors raise the question of the sculpture's "relation with African life"; second, one in which they conduct a precise analysis of "its artistic qualities"; and third, photographic images of "forty-three Negro sculptures." Are these sculptures and the works of the black continent in general, as discovered by ethnologists and European artists, the expression of African life? Guillaume and Munro's answer

is unequivocal: no. The situation henceforth for Africans
on the continent and in the diaspora does not have much
to do with the material and spiritual reality of the Africa
of old, the Africa which it would have been possible to
think of as reflected in the works of art that give witness,
in their enigmatic way, to what used to be. Regarding the
continent, it is necessary to begin with the colonial situa-
tion and, for America, with the world as it is after slavery:
both created different Africans "in process of civilization"
and it is useless to try to find in these "evolved" people, as
the authors also call them, the state of mind of the artists
who created the works we can still admire today.[19]

It is a mistake to believe that we can think of the trans-
formation of the African world as resulting from a simple
addition of an exterior to a substrate that would be pos-
sible to isolate and examine. To pursue the question of the
relation between African art and the identity of Africans is
to interrogate a mute mirror. There is no essence towards
which masks and sculptures point, no Africanity to be re-
trieved and examined behind its metamorphoses either on
the continent or in the diaspora. Guillaume and Munro
also pull no punches in affirming the consequence of this
observation: by destroying the gods of traditional Africa,
"civilization" destroyed its art and henceforth Africans
have "lost their genius for plastic form."[20] The artist, the
one who invented these forms, has disappeared along with

the secret of what it meant at that time to sculpt *like that*. To try at all costs to establish a continuity with today is, for Munro and Guillaume (the collector of African art), to open the way to counterfeiters and the poor imitations of the "occasional uninspired craftsman...chipping wood or ivory into a stiff, characterless image for the foreign trade."[21] This characterizes what we would today call "airport art," produced by those who no longer invent anything and who are condemned to the indefinite imitation of their own tradition which has become opaque and silent.[22]

If, then, we can no longer ask what *was meant*, we remain free to pose the question of what sculpting like that *means* for us today. That is the only true question. For Guillaume and Munro, the bright side of the lack of continuity between the artist who created the great works of Negro sculpture and the African world today is precisely the fact that this break frees us from worrying about reconstituting the Africanity that would supposedly provide the key to understanding this art. We can and we must "forget who made it and look at it afresh."[23] Those who do not look afresh can be divided into two groups. One, the ethnologists who, Guillaume and Munro tell us, are attached to producing "abstruse metaphysical theories"[24] that are supposed to explain the African mentality. They put between us and the work of art a set

of considerations—descriptions of ethnic groups, rituals, etc.—which do little to illuminate it and, on the contrary, manage to obfuscate it.

Then there is the group of European artists whom we might have thought, given that they were the first to recognize this form of art at the base of modern tendencies, to be most qualified to speak about it. What we discover instead is that the discourse of this group does not go beyond "extravagant" praises: the artists find themselves struck impotent before the forceful reality of the works, feeling intuitively their quality while remaining "inarticulate when it comes to expressing their feelings" and producing, in the end, only "vague rhapsodies, flowery, incoherent, confused."[25] We can add to these two types of discourse that of the professional art critics, whose jargon-laden chattering very often manifests nothing but their own preferences: they too fail to explain to us the nature of the satisfaction provided by works of African art.

In contrast to all of these discourses, we need to rely on what is in the work itself, here and now, in the present moment in which it offers itself to us, rather than on what we take to be its necessary context. By thus dismissing the concern for context in order to return to the artistic thing itself and start from there, Guillaume and Munro ask that we learn to read African art by forgetting whatever is not directly there: everything besides its artistic

qualities themselves. They thus adopt an approach to art appreciation that consists in focusing on the art object as it is, describing it while bracketing out those who created it and discarding preconceived ideas. The approach is defined as follows:

> It differs from most art criticism in trying to avoid subjective reverie and unverifiable generalization, and in the systematic attempt to see instead, as clearly and objectively as possible, the demonstrable qualities in the works of art themselves, and their relation to conscious processes of the observer. An attempt is made to consider the plastic qualities of the figures—their effects of line, plane, mass and color—apart from all associated facts.[26]

In this approach, we find the formalism associated with Clive Bell, a philosopher of art, whose influence is visible here. Indeed, it is he who insisted most on the necessity of reading the art object by confining oneself to its pure form isolated from all significance situated outside of it. It is necessary to be able to perceive with the eye of the artist for, at that point, "having seen it as pure form, having freed it from all casual and adventitious interest, from all that it may have acquired from its commerce with human beings, from all its significance as a means," we

can feel "its significance as an end in itself."[27] It is when we are thus dealing with a universe of pure forms that we can answer the question: "Why are we so profoundly moved by certain combinations of lines and colors?" The answer is: "Because artists can express in combinations of lines and colors an emotion felt for reality which reveals itself through line and color."[28] Thus is born "significant form" which is the "form behind which we catch a sense of ultimate reality."[29]

In order to keep away outside considerations, it is necessary to dismiss not only the context but also, with regard to the onlooker, certain expectations created in him by his history and his taste as constituted by this history. The subject must first be informed about *what is not* in the work but which, unconsciously, because he learned to find enjoyment in the *Venus de Milo* or the *Apollo Belvedere*, he expects to find there. To provide an education in African art that has not been reduced to the single value of a testament to Africanity, Guillaume and Munro begin by contrasting it with "classical" art. Learning how better to enjoy the plastic qualities of African sculpture requires, first of all, an understanding of the nature of enjoyment one gets from Greco-Roman statuary, since it is the point of reference for European art. The question then becomes that of the erotic in Greek statuary versus African sculpture. This explains the choice of canonical

works such as the representations of Venus/Aphrodite, Goddess of Beauty, and Apollo, her male equivalent. The goddess and the god as they are represented in Greco-Roman statuary express the ideal of the human form, its perfection. The erotic here belongs, then, to the category of "the pleasant to look upon," which itself translates as that which we wish to resemble or to lovingly possess. The enjoyment the work of art provides stems from the caress of the glance and perhaps the hand, as the body puts itself mentally in the posture of imitating or embracing. Other works, without having so explicit a link with love or the ideal of physical beauty, belong no less to this category of mimetic pleasure: we are made to mentally smile by the "shrewd, whimsical smile" of Voltaire when looking at the bust of the philosopher sculpted in 1778 by the neoclassical artist Jean-Antoine Houdon; likewise, we break loose towards freedom with Michelangelo's *Rebel Slave* (1513) by feeling in our body, as frail as it may be in comparison, all the energy of his powerful muscle structure.[30]

To approach African sculpture without preconceived ideas is to not expect to see this category of mimesis work there and to learn, by opening up to it, to see a different erotic register activated. Does the African spectator also feel like kissing the Venus? By God, yes! Does he want to hold in embrace the "deformed" maternity idol from Guinea? No, thank God! Considered in relation to the category of

"the pleasant to look upon," this work and others where the natural form of the human body is deformed and *dislocated* are, for any subject, "a freakish monstrosity."[31] In relation to this category, these works cannot help but reveal themselves as ontologically lacking or as demonic inversions, which is what the missionaries of revealed monotheisms (both Christianity and Islam) did not fail to assert as they attacked the "fetishes." How then are we moved by this form of art? How is it that, "with experience and a determined open-mindedness to new sensations," we find the beauty that is contained in the African statue?[32] We could content ourselves with an appeal to habituation which brings it about that "some things which first seem ugly come to be pleasing on further acquaintance," a bit like how we become accustomed to eating spicy food.[33] But there is another, more positive way to understand what Guillaume and Munro are saying: it is not custom that leads us progressively to art's truth; rather, this truth is grasped through the initial experience of the eidetic reduction in which it is perceived that what appeared at first as a "distorted copy of a human body" is in fact "a new creation in itself."[34] It is this initial truth that will subsequently manifest itself more clearly through custom.

What is this truth of African art for Guillaume and Munro? What is the nature of the non-mimetic pleasure that we get from "primitive negro sculpture"?

[I]t is apt to be unmeaning or even disagreeable to civilized people. But in shapes and designs of line, plane and mass, it has achieved a variety of striking effects [*"effets puissants,"* in the French translation] that few if any other types of sculpture have equaled. These effects would be impossible in a representation of the human figure if natural proportions were strictly adhered to. They would be impossible in an ideal figure conceived, like the Greek ones mentioned, on a basis of what would be humanly desirable in flesh and blood.[35]

We find here once again the register of the *power* of effects born of excess and the absence of proportions in the name of another logic internal to the work, a logic which does not aim at the pleasure of a "beautiful reality" consonant with our normal faculty of desire for what is "flesh and blood" but at the shock caused by the "free play of impulsive feeling," which is itself the image of the figure *"dissociated into its parts,* regarded as an aggregate of distinct units."[36] Enjoyment is derived here from an experience of limits and from the transmutation of the fear of seeing unity lost and "the whole piece...fall apart" and become "confusingly unrelated" into the surprise of sensing that the work has found "means to weld the contrasting themes together by some note common to

both."[37] It is by a music composed at will, Guillaume and Munro claim, that we find ourselves possessed when we walk around an African statue as "its lines and masses flow constantly and infinitely into new designs and equilibria, with no hiatus or weak intervals between."[38] Music here is more than a metaphor. The plastic work is not like music: it *is* a "complete visual music" in which

> contrasting rhythms affect the sensitive eye and brain as a series of powerfully reiterated shocks in line, ridge, and roughened hollow, alternated with smoother intervals, like recurring bursts of drums and brasses in music. Distributed, spaced, contrasted, welded firmly together by repetitions of them, each shape is given its maximum esthetic effectiveness, and the power of the whole is made cumulative, brought to a focus by the unity of design.[39]

All in all, Guillaume and Munro's formalist approach invites us to place ourselves within an ontology of rhythms so as to fully grasp the nature of the world we are led into by African sculpture and the nature of the emotion it provokes as an effect of its powerful and violent stimulants. Creation consists here in the composition of rhythms, in building a rhythm from units, which are themselves rhythms, by repeating them without repeating

them exactly and by making them respond to each other through contrast and inversion.[40] This is indeed what Senghor will do, as this text will always continue to show through in his work, above all when he writes on African art, emphasizing as he will that it is based on rhythm or vital force or even the oxymoron he coins to express that which gives this art its most distinctive characteristics: asymmetrical parallelism.

ONTOLOGY OF RHYTHMS

It is in "What the Black Man Contributes" that Senghor writes the sentence to which his thought has often been reduced, generally for the sake of rejecting it altogether with a single gesture: "Emotion is Negro, as reason is Hellenic" (*"L'émotion est nègre, comme la raison héllène"*).[41] The numerous comments it has provoked have not paid enough attention to certain important factors. The first is the choice of the word: "Hellenic" rather than "Greek" or even "European," which he will later use.[42] Is this but a stylish touch by someone who, as a *khagneux agrégé de grammaire*,[43] was nourished by Classics? Is it the choice of a poet fond of the rhythm of the alexandrine, since it is true that, on the level of euphony, *"héllène"* proves obvious and necessary to the ear? This is all no doubt true, but the sentence also makes reference to the

contrast between Greek statuary and African plastic art on which the authors of *Primitive Negro Sculpture* based their analysis of difference in aesthetic pleasures.[44]

The second important factor is the context: Senghor's article is really oriented towards its last section, which is dedicated to what for him is the major contribution of Africans to the world of the twentieth century: art. Further, in the lines immediately following the sentence, Senghor explains the concept of emotion by means of the notion of *rhythmic attitude*, thus foreshadowing his discussion of art. "Emotion is Negro, as reason is Hellenic" can thus be understood, in the context in which it appears, in the following manner: emotion is to African works of art what reason is to Hellenic statuary. I will also contend that it is in Senghor's aesthetic reflections that what is primarily and above all an *analogy* found its meaning before it was transferred, no doubt less felicitously, to the field of epistemology. Because his readings on African art (in particular, the work of Guillaume and Munro) encouraged an approach contrasting statues in the Hellenic tradition and African sculpture, Senghor too positions himself from the start within this polarity.

Given that he was trying to establish "what the black man contributes," Senghor quite obviously could not subscribe to the way in which Guillaume and Munro's book invites us to "forget" the Africans in order to better

understand and enjoy the art their continent has given the world. We can easily imagine that he saw himself as writing against the tranquil racism, normal in colonial times, of authors who declare that outside of a few "traditions"—like the idea that "as early as the third century AD" the empire of Ghana (whose "probable capital ruins have lately been discovered") was "flourishing in the Western Sudan"— "the negroes are a people without history" whose "past can be described only in terms of general racial intermixtures."[45] A reaction against this finds weighty support in what Senghor presents as the most important reading that he did with his companions in Negritude, some three years before the publication of "What the Black Man Contributes": the reading of Leo Frobenius.[46] Senghor needed to bring back to African art the Africanity that Guillaume and Munro had somehow driven from it. His studies at the time with the Africanists at the Paris Institute of Ethnology and at the Ecole pratique des hautes études prepared him to restore the link between African sculpture and *ethnos*, to "re-ethnologize" art. He does so by, above all, following Frobenius on African civilization but without giving up the approach of *Primitive Negro Sculpture* that consists of focusing attention on the art's plastic qualities themselves.

In Frobenius, Senghor finds support for his idea that African art expresses an African "spirit" and perhaps a

"being-African." We can guess how strongly he agrees with the following lines by the German ethnologist when he reads them in *Der Ursprung der afrikanischen Kulturen* (1898; The History of African Civilization):

> And wherever we can still find evidence of this ancient [African] culture, it bears the same stamp. When we walk through the great museums of Europe—the Trocadéro, the British Museum, the museums in Belgium, Italy, Holland and Germany— we recognize everywhere the same "spirit," a similar character and essence. Whichever part of this continent the various articles have come from, they unite in speaking the same language.[47]

And, later, in the same text:

> This is the character of the African style. Anyone who comes close enough to it to truly understand it soon recognizes that it prevails *throughout Africa* as the very expression of its being. It manifests itself in the gestures of all Negro peoples as much as in their plastic art; it speaks in their dances and in their masks, in their religious sentiments as well as in their modes of existence, the forms of their polities and their destinies as peoples. It lives in their fables, fairy tales, legends and myths.[48]

There is an African style which unifies the continent and, in it, *Being* expresses itself as a spirit spanning the ages, a "language" that continues to be spoken in all the aspects and gestures of African life: this is what Senghor too wants to assert (against Guillaume and Munro). If we should not take ethnographical knowledge as a *starting point* in interpreting art, since that would only obfuscate our understanding of it, it still remains that this understanding ought to *bring us back* to an African way of seeing things and to African life in general. It is true that the authors of *Primitive Negro Sculpture* admit that the art of Africans (or rather, the art created on the continent during the time of their ancestors) could constitute a source, "the most revealing" one which we could find, "for understanding the primitive negro mind."[49] But Senghor is also interested in establishing an organic continuity with African life today, however altered it may be, and with life in the black diaspora, however alienated it may be. It is for the sake of this continuity that he puts ethnology at the center of his philosophy: in order to make Africans visible after *their* art has become visible. To bring Africans out of their invisibility and make them appear as real "antagonists," that is to say, "interlocutors": this too was proposed by the man Senghor always calls his teacher—Frobenius.[50]

If it is to this teacher that Senghor appeals in order to restore the link between African life and the sculpture to which it gave birth, it is nevertheless the strictly formalist

approach of Guillaume and Munro that is decisive for his philosophy of African art. It is decisive, above all, for the way in which he elaborates his notion of *rhythm*. Here is how he speaks about it in "What the Black Man Contributes":

> This ordering force that constitutes Negro style is *rhythm*. It is the most sensible and the least material thing. It is the vital element par excellence. It is the primary condition for, and sign of, art, as respiration is of life—respiration that rushes or slows down, becomes regular or spasmodic, depending on the being's tension, the degree and quality of the emotion. Such is rhythm, originally, in its purity, such is it in the masterpieces of Negro art, particularly in sculpture. It is composed of one theme—sculptural form—that is opposed to a brother theme, like inhalation is opposed to exhalation, and that is reprised. It is not a symmetry that engenders monotony; rhythm is alive, it is free. For reprise is not redundancy or repetition. The theme is reprised at another place, on another level, in another combination, in a variation. And it produces something like another tone, another timbre, another accent. And the general effect is intensified by this, not without nuances. This is how rhythm acts, despotically, on

what is least intellectual in us, to make us enter into the spirituality of the object; and this attitude of abandon that we have is itself rhythmic.[51]

This reflection on rhythm is echoed, 17 years later, by the following lines:

> *What is rhythm?* It is the architecture of being, the internal dynamism that gives it form, the system of waves it gives off toward *Others*, the pure expression of vital force. Rhythm is the vibrating shock, the power which, through the senses, seizes us at the roots of our *Being*. It expresses itself through the most material and sensual means: lines, surfaces, colors, and volumes in architecture, sculpture and painting; accents in poetry and music; movements in dance. But, in doing this, it organizes all this concreteness toward the light of the *Spirit*. For the Negro African, it is insofar as it is incarnate in sensuality that rhythm illuminates the Spirit.[52]

And when he speaks once again of repetition, it is to clarify that "there is almost always the introduction of a new element, variation in the repetition, *unity in diversity*."[53]

Let us consider first the passage on rhythm in "What the Black Man Contributes." If Senghor's discussion of

African art is at the center of his writings, then this paragraph on rhythm is at the center of that discussion. We see here the way in which Senghor takes up and reworks the remarks of Guillaume and Munro. What he says at the beginning of the quote about rhythm as a condition of African art responds to the way in which, in *Primitive Negro Sculpture*, the artist in front of the work to be created is described as taken away by the rhythm that imposes itself upon his imagination—he is, we are told, "obsessed" with it—and into which "he will force the yielding block."[54] Thus, for Guillaume and Munro, at the beginning of creation is the rhythm that will harness the matter and whose primary form is repetition. The work is made of "plastic rhythms"[55] responding to one another in repetition and contrast, as is shown in the following analysis of a mask that we can imagine Senghor reading with the greatest attention:

> …[T]he mask has a direct aesthetic effect, independent of all associations, by the shapes and combinations of its part. The eyes are rough, irregular circles, boldly outlined; the huge upper lip, as a semicircle, relates the mouth to them and joins in a *rhythmic series* that is continued above the eyes. The lower lip, a stiff contrasting horizontal, relates the mouth to the base of the nose and to the horizontal lines of the forehead, and thus sets *another rhythmic series* in

motion. The nose, a sharp-edged pyramid, is echoed in the line of rough, ribbed cones of hair that march across the forehead. The vertical ridge above the nose connects it with the hair, bridging an otherwise blank expanse, and helps to balance the heavy massing of features at the bottom. It joins with nose and mouth to form a wedge-shaped subordinate pattern; to right and left of this wedge, as a result, are two shield-shaped planes, each pierced by an eye, and each a version of the face's total contour. These *contrasting rhythms* affect the sensitive eye and brain as a series of powerfully reiterated shocks in line, ridge, and roughened hollow, alternated with smoother intervals, like recurring bursts of drums and brasses in music. Distributed, spaced, contrasted, welded firmly together by repetitions of them, each shape is given its maximum esthetic effectiveness, and the power of the whole is made cumulative, brought to a focus by the unity of design.[56]

From his reading of Guillaume and Munro, Senghor forever retains this approach to the African art object as a combination, a unity of rhythmic series that respond to one another. What he adds is turning this into the language of African ontology, an ontology of vital force. Behind forms, for him, there is metaphysics. Indeed, he insists

on a meta-aesthetics: "The painters and the sculptors of the School of Paris...saw [in African sculpture] essentially an aesthetics while, beyond the laws of the beautiful, it also expressed a meta-physics, I mean an ontology, and an ethics."[57] Senghor thus shares Bell's philosophy of art and what the latter calls the "metaphysical hypothesis." The question "Why are we so profoundly moved by certain combinations of forms?" is not, for Bell, an aesthetic question but a metaphysical one.[58] It leads us beyond the emotion and the object that provoked the emotion to "surprise that which gives form its significance."[59] For the artist possesses a particularity that makes him a guide towards this *beyond*:

> the peculiarity of the artist would seem to be that he possesses the power of surely and frequently seizing reality (generally behind pure form), and the power of expressing his sense of it, in pure form always. But many people, though they feel the tremendous significance of form, feel also a cautious dislike for big words; and "reality" is a very big one. These prefer to say that what the artist surprises behind form, or seizes by sheer force of imagination, is the all-pervading rhythm that informs all things; and I have said that I will never quarrel with that blessed word "rhythm."[60]

As for Senghor, he does not hesitate a moment to say that the artist discovers "reality," or rather what he calls "sub-reality," and that the latter is made up of *rhythms*.

Even before Senghor reads Tempels' *Bantoe-filosofie* (1949)[61] immediately after the Second World War, the idea that African art expresses the ontology of vital force is already present in his thought: he speaks of an "ordering force" which is "the vital element par excellence," thus inviting us to think of sculpture and ontology together. The discovery of Tempels' work, which he greets with overflowing enthusiasm, allows him thereafter to be more precise in his presentation of the universe of the artist as the true reality: the reality of vital forces, which, he says, constitute the fabric of reality.[62]

Tempels' thesis can be summarized as follows: to understand "African life" in its multiple manifestations, whether in terms of religion, art, ethics, medicine, law or government, involves going beyond ethnographic descriptions in order to reach knowledge of the ontology that is the *ratio essendi* ("reason for being") and *ratio cognoscendi* ("reason for intelligibility") of the things these descriptions present without managing to examine their true significance. This ontology which gives meaning to everything else expressed in the following equation: Being *is* force. Not that force is an attribute, even an essential one, of what is; what is meant, rather, is *ens sive robur*: Being, *in other words*, force.

The true reality, the *powerful* reality about which Picasso spoke and which Senghor prefers to call the *sub-real* rather than the surreal so as to better indicate that it is what is *under* appearances, the energy under the thing is thus the reality of *pluralistic energetism*, as the Belgian philosopher Leo Apostel characterizes it. Apostel summarizes *Bantu Philosophy* in the following seven theses:[63]

1. To say that something exists is to say that it exercises a specific force.

2. Every force is specific (as against a pantheistic interpretation, since what is asserted here is the existence of monadic, individual forces).

3. Different types of being are characterized by different intensities and types of forces.

4. Each force can be strengthened or weakened (*reinforced* or *de-forced*, as Senghor puts it).

5. Forces can influence and act upon each other in virtue of their internal natures.[64]

6. The universe is a hierarchy of forces organized according to their strengths, starting from God and going all the way down to the mineral through the founding ancestors, the grand dead, living humans, animals and plants.

7. Direct causal action involves the influence of more-Being, or stronger force, on less-Being or weaker force.[65]

Is this universe of forces the one inhabited by Africans? It undoubtedly makes no sense to proceed to such a generalization which in turn leads towards the idea—justly critiqued by Paulin Hountondji—of a collective philosophy. On the other hand, it is perfectly possible to hold that this ontology is that which is accessed, as the true *sub-reality*, by the initiated, the sages. We can thus also include artists, who know better than anyone else how to find the door to this world. "If the hierarchical and pluralistic energetism that is described as Africa's most original contribution to philosophy is no myth," writes Apostel, "then it should find its expression in African art"; and he adds: "We believe that this is indeed the fact."[66] For Senghor, certainly, Negro art is the proof of Negritude. If the artistic work provides access to the ontology characterized as pluralistic energetism, it is because it constitutes that ontology's language. Senghor can be read as adding to the seven theses of *Bantu Philosophy* the following:

(a) What constitutes the individuality of a given force is its *rhythm*.

(b) We open up ourselves to the object, the art object in particular, by means of a *rhythmic attitude* that puts us on the same wavelength with it, i.e., with its rhythm: this is what it means to be in touch with its *spirituality*.

(c) The harmonious combination of rhythms in a
work of art depends on a force/rhythm which
orders the whole into an indivisible organic
unity.

In this sense, the whole precedes the parts that it
orders just as music or rhythmic lyrics are prior to the
words that constitute them. It is not surprising then that
the poet Senghor's philosophy of art would be a phi-
losophy of inspiration, nor that on this point it meets
with Bergson's thought. Senghor will define himself as a
hearer before anything else and, like all the poets of the
anthology, as a "singer…tyrannically subjected to 'inner
music,' and primarily to rhythm."[67] What Sartre wrote of
Césaire's poetry, noting that the words of the latter "are
compressed, one against the other, and cemented by his
furious passion,"[68] Senghor echoes in the following lines:

> when [the poet] writes a poem, he does not calculate,
> he does not measure, he does not count. He does not
> look either for ideas or for images. He is, in front
> of his vision, like the black Great Priestess of Tanit,
> in Carthage. He speaks his vision, in a rhythmical
> movement, because he is impassioned with a sacred
> passion. And even his song, the melody and rhythm
> of his song are dictated to him.[69]

The rhythmical movement is a whole, indivisible. It is the ideal of creation, from which alone the "joy" Bergson speaks about can be born: the joy that informs us that the destination is reached when the inner rhythm is in perfect symbiosis with the transcribed rhythm.[70] If African sculpture can be said to be "Cubist," it is not because it analyzes the object into separated elements, *partes extra partes* (one part external to another), before recombining them; on the contrary, it is because it insists on the indivisibility of the whole, on the total effect where all the rhythms which melt into it converge.

Once again, it is important to emphasize that Senghor has a plastic understanding of rhythm, given that he first met with it as a principle of creation and as the supreme aesthetic value in the art of sculpture before discussing it in relation to those areas more immediately associated with it (like poetry, music or dance).[71] "Reading" a feminine Baoulé statuette in the manner of Guillaume and Munro describing the Fang mask, Senghor causes it to speak "in music":

> In it, two themes of sweetness sing an alternating song. The breasts are ripe fruits. The chin and the knees, the rump and the calves are also fruits or breasts. The neck, the arms and the thighs are columns of black honey.[72]

What in the language of Guillaume and Munro we would call the "rhythmic series" of fruits/breasts, is here referred to by Senghor as a "song" or a "theme of sweetness," which alternates (Senghor) or enters into opposition (Guillaume and Munro) with the rhythmic series of the "columns of black honey." If it is possible to move in this way from plastic language to musical language, it is because the ontology expressed in sculpture and in poetic song is the same: an ontology of rhythms.

PLURAL REASONS

Senghor is obsessed with the Negritude once claimed by Arthur Rimbaud and he quotes very often the latter's famous words from *Une Saison en Enfer* (1873)[73] which mark his break with the European world:

> Yes, I close my eyes against your light. I am an animal, a Negro...The cleverest thing to do is to leave this continent, where madness roams, searching out hostages for this dismal bunch. I am entering the true kingdom of the children of Ham.[74]

In "Lettre à trois poètes de l'Hexagone" (1979), Senghor, more so than quoting Rimbaud, proceeds to a veritable collage of the latter's phrases, taking them from here and

there in order to end up with what he declares to be a Negro-African re-reading of Rimbaud:

> I am an animal, a Negro. But I can be saved. You people are *phoney Negroes...I invented the color of vowels!* I organized the shape and movement of every consonant, and, by means of *instinctive rhythms,* flattered myself that I was the *inventor of a poetic language,* accessible sooner or later to *all the senses.*[75]

It is not only the collage effect which constitutes a veritable re-reading but also the choice to emphasize this or that word and this or that expression. What this re-reading sketches, then, and what Senghor presents in his commentary as the suggestion of a "radiant symbolism in which all the senses—sounds, smells, flavors, touches, forms, colors, movements—maintain mysterious correspondences and give birth to analogical images"[76] is once again an ontology of rhythms. Rimbaud has arrived at the sub-reality, to what reality is made of, to find that its elements are primary, "instinctive" rhythms. He has gone beneath language and the words with which language is made to the vowels which are the primary colors and to the forms and primary movements that are the consonants. Like an alchemist witnessing creation from primary elements, he has then *seen* and *heard* how these

rhythms combine in a poetic language which is in tune with all the senses.

So here we have Rimbaud's alchemy of the word pointing towards the same *pluralistic energetism*, towards the same ontology Tempels described as being at the root of Bantu philosophy. Should we take seriously the "Negritude" of Rimbaud, this claiming of the word "Negro" because it signified in his eyes radical *alteration*, the most complete achievement of the "I" as an "Other"? Why, after him, consider Paul Claudel or Charles Péguy or even Saint John Perse as "Negro poets" as well?[77] Senghor has a tendency to negrify all that evokes for him the ontology of vital force. This approach—above all when it is coupled with a concern, at times racializing to the point of absurdity, to locate black influences (i.e., traces of blood) or "characterological" affinities—does not fail to irritate.[78]

Ultimately, though, this racialization ends up neutralizing and destroying itself. If there is a Negro style that expresses itself in the juxtaposition of rhythmic series which respond to each other in an asymmetric parallelism, then we can see things this way: this style is not the natural emanation of something like a "race" but rather the choice of, the preference for, and perhaps the religious and aesthetic obsession with, a particular *form*: that of parataxis, which Senghor opposes to syntax. Thus he and Césaire recognized themselves in Tristan Tzara because of

the Surrealist poet's taste for " 'parataxis,' i.e., the replacement of syntax by juxtaposition or coordination, [in which] melody is made of 'the noises and sounds' of nature."[79] The fact that Senghor's racialism ends up negating itself is something we recognize when we read him attentively. Let us consider the following passage, a part of Senghor's conclusion to his "L'esthétique négro-africaine" (1956):

People will say that the spirit of the Civilization and the laws of Negro African Culture, as I have exposed them, belong not only to the Negro African, but are held in common with other peoples as well. I do not deny it. Every people unites on its face the various features of the human condition. I claim, however, that nowhere else do we find these features united in this equilibrium and under this light: nowhere else has rhythm reigned so despotically. Nature did well, desiring that each people, each race, each continent would cultivate, with a particular dilection, certain virtues of Man; in this cultivation resides their originality. If it is added that this Negro African Culture resembles, like a sister, that of ancient Egypt, of Dravidian peoples and of Oceanian peoples, I shall answer that ancient Egypt was African and that there is black blood that flows in passionate streams through the veins of Dravidians and Oceanians.[80]

We are certainly dealing with racialism when the epidermis of Dravidians and Oceanians determines their essential Negritude. Nevertheless, the definition of what constitutes difference or specificity—what is called here *originality*—also puts racialism in question. What constitutes originality, Senghor tells us, is not a specific feature that would belong solely and exclusively to one race but, rather, a certain "equilibrium," let us say a certain ratio, between various features that can be found everywhere because together they make up the human condition. Different cultures, then, will be characterized by different ratios between the same features that they combine in separate ways. It will thus be no mystery (needing to be explicated by scrutinizing influences, biology or characterology) if cultural practices breaking with or revolting against the customs and traditions of the context of their birth can sometimes recognize themselves in the mirror offered by an *alternative* way of establishing a ratio between the features which define the human condition. In this way, Rimbaud can declare himself Negro and Claudel can have, in Senghor's eyes, a spirit and a style the latter considers African. In the same way, we can say that Picasso would never have encountered, at the museum of Trocadéro, the *alternative* answers to the problem of artistic representation which he saw embodied in the African masks that he discovered there if he had not

himself brought with him the *alternative* questions then haunting him.

Underneath his differentiations, there appears at all times in Senghor the vision of an indivisible human condition, putting the differentiations in perspective and perhaps negating them. This is the case when we consider his philosophy of African art in which, even when he insists on the specificity of the Negro African aesthetic, it is ultimately for the purpose of making it one of the possibilities available everywhere, in all cultural spheres and in various ages, to human creativity. On the other hand, the rhythmic attitude for him is not confined to the aesthetic domain alone; it is, in a general sense, an approach to reality and a means of knowing it. With respect to this artistic knowing which is opposed to Hellenic reason, we may wonder whether he does in fact construct that specificity of difference that terminates in the creation of a separated humanity.

CO-NAISSANCE

Art is a means of knowledge.

Léopold Sédar Senghor[1]

BERGSON: THE REVOLUTION OF 1889

BERGSONIAN PHILOSOPHY TRULY marks the end of a paradigm.[2] After the "closed world" as envisioned by Aristotle and maintained for close to two millennia had been destroyed, René Descartes, in order to begin the philosophical enterprise anew, had given himself the model of mathematics because of "the evidence of its reasonings."[3] In the nineteenth century, however, a deep rupture is produced once the life sciences choose to base their future development on the rejection of Cartesian mathematicism. The philosophy of Bergson (who, according to Paul Valéry, "found inspiration in biology")[4] is born of a complete understanding of this new situation, a total grasp of what the development

of the biological sciences means for our way of thinking in general.

But beyond simply Cartesian philosophy and the mechanism of Galileic-Cartesian science, what Bergson breaks with when, in 1889, he publishes his doctoral thesis under the title *Essai sur les données immediates de la conscience* is an even older tradition. It is, before this and more deeply, the entire orientation of philosophy (at the very least, in what we call the Western world) since it committed itself, after the Pre-Socratics, to thinking in terms of a radical opposition between Being and Becoming. The reason for this commitment is that it saw in this opposition, first of all, the very condition of the possibility of a true intelligence or understanding of things. If what we have is, on the one side, the path of being and, on the other, that of non-being, the choice is quickly made. The Eleatic paradoxes are the proof: that which is always in the process of becoming otherwise escapes the intelligence which is then understood as the capacity to fix, to hold being within one's gaze, thereby keeping it within the realm of the identical. One will thus choose the way of reason, this reason that we can call (using an expression of Senghor's) *eye-reason*, because it is the look that freezes. To think, in this way, is to immobilize.

Proceeding thus, philosophy forbade itself thereafter from thinking about what it could not really immobilize:

motion, time. As it cannot grasp these, it will do *other-wise*. Time will be conceived as measure, the "number of motion in respect of before and after," as Aristotle puts it.[5] A physics of motion will be possible: fix "before" at instant t_n and "after" at instant t_{n+1} and, consequently, motion becomes the *trajectory* that goes from t_n to t_{n+1} while time is nothing but the *interval* separating these two immobile points. Of science so constituted, Bergson writes:

> [It] cannot deal with time and motion except on condition of first eliminating the essential and qualitative element—of time, duration, and of motion, mobility. We may easily convince ourselves of this by examining the part played in astronomy and mechanics by considerations of time, motion and velocity.[6]

If this is the path that was followed, it is because it was practical. Science's goal, even in its most theoretical and disinterested appearance, is always to act on things, to render ourselves (as René Descartes put it) "masters and possessors of nature."[7] It is therefore natural that, pursuing its practical ends, science gave itself the means of mastering motion by making it into a formation of immobile points and time by making it into a series of moments:

Science may consider rearrangements that come
closer and closer to each other; it may thus increase
the number of moments that it isolates, but it always
isolates moments. As to what happens in the interval
between the moments, science is no more concerned
with that than are our common intelligence, our
senses and our language: it does not bear on the in-
terval, but only on the extremities. So the cinemato-
graphical method forces itself upon our science, as it
did already on that of the ancients.[8]

What would it mean to be interested in "what happens
in the interval"? Beyond the senses, resisting the natu-
ral slope along which our language inclines us to think,
we would aim to *be with* change itself rather than isolate
the positions of that which changes: we would embrace
flux itself. The faculty we would then be putting to work
would not be eye-reason. It would be what we can, once
again with Senghor, call *embrace-reason*. How does it
work? Certainly not by decomposing motion in order to
freeze it; certainly not by *analysis*. The immediate embrace
of an undivided whole in an act of sheer intuition: this
is how embrace-reason operates. It does not, therefore,
place the object in front of itself; rather, it places itself in
the object, marrying its flux. We might say that it dances
rather than thinks the object—*elle le danse plutôt qu'elle*

ne le pense—to use the rhyming play on words in which
Senghor sums up his notion of an *alternative* knowledge
in which we see what he owes to Bergson.

Was it really a choice to take the path of intelligence
rather than that of this other faculty which comprehends
that which fluctuates? Was it a matter of weighing the pros
and cons in a deliberation where practical considerations
finally won the day? Of course not: it is the very motion of
life that chose. It is evolution that, over the course of the
ages, fashioned human intelligence as the faculty that deals
with the inert which it decomposes and recomposes, the
faculty "preoccupied in welding the same to the same,"
the faculty that, by its nature, remains within the realm
of the identical.[9] In our language, it is this intelligence that
speaks. Yet it is impossible that life is completed and frozen
in the inert, for life is wider than intelligence, which is in-
cluded within it: "We do not *think* real time. But we *live*
it, because life transcends intellect."[10] At a certain point
in evolution, Bergson explains, vital activity experienced a
bifurcation along two paths: on one hand, the path of intel-
ligence, which deals with the inorganic and which is "char-
acterized by a natural inability to comprehend life," and,
on the other, the path of instinct, which is turned towards
life and which, in humanity, becomes *intuition*—that is, it
becomes "disinterested, self-conscious, capable of reflecting
upon its object and of enlarging it indefinitely."[11]

If I have spent so much time on Bergson and, in particular, on his theory of knowledge, it is because in many respects, as we have already begun to see, this theory is also Senghor's, with the addition of his Negritude. Senghor consistently maintains that it is the emergence of Bergsonism in the history of philosophy in the West, which he calls "the Revolution of 1889," that made possible the very questions that Negritude poses. The *alternative* philosophy (*philosophie autre*) that is Bergsonism, which radically changed the direction taken by thought since Plato and Aristotle, is also that which enabled the articulation of a *philosophy of the Other* (*philosophie de l'autre*): that is, other than European. The tools that Bergson provides to the Senghorian enterprise of saying philosophically that which is *other* are, essentially, vitalism and intuition.

First, then, there is the thought that Being is vital motion rather than immobility. Senghor is perfectly Bergsonian when he writes, in the text of an important speech he gave at the Nordic universities in May 1970: "Until the nineteenth century, for over two thousand years, European thought neglected the brilliant intuitions of a whole line of Greek philosophers and lived, more or less, on Aristotle's thought, in which *logos*, which used to be damp and vibratory, became crystallized in rigid categories that no longer embraced or translated

shifting, lively reality."[12] The Bergsonian atmosphere in which Senghor's thought was formed quite naturally prepared him to receive with much enthusiasm the first works to take a philosophical approach to the African conceptions manifest in the religions and languages of the continent and claim that at the foundation of these is a *non-static ontology* of vital forces, inviting us to think of non-Aristotelian categories of being.[13]

The rehabilitation of intuition carried out by Bergson is crucially important for Senghor's thought. The idea that "scientific knowledge must appeal to another knowledge to complete it" or that "[c]onsciousness, in man, is preeminently intellect" but "[i]t might have been, it ought [. . .] to have been also intuition" has a very particular resonance for him and serves, to begin with, to reframe the discourse of ethnologists.[14]

ALTERNA-LOGIC:
THE ETHNOLOGY OF LUCIEN LÉVY-BRUHL

Senghor once wrote that ethnology needs to be as much a part of the basic curriculum as does French. The reason for this is that, for him, the discipline is a humanism in itself: what one learns from it, at the end of the day, is humanity insofar as it is *one* in its differences.[15] That there is not one but multiple civilizations offering as

many different faces of the human adventure is, according to Senghor, the fundamental lesson to be found in ethnology, which is *ipso facto* an ethics that forbids racism or cultural contempt. *Ethnography* (which, from the beginning of the discipline, made curiosity about otherness its objective) thus leads to a kind of *ethnological wisdom* by starting from a reflection ultimately concerned with humanity in the singular: the study of men in their differences necessarily has as its backdrop the question "What is Man?" In this sense, to take the example of an ethnologist that Senghor cites often, Marcel Griaule, who when listening to the words of the Dogon sage Ogotemmêli about the myths of his people or wondering about the meaning of their works of art, is not being curious about a completely different world (or not only that) but is exploring humanity in general.

Nevertheless, in the early years of the twentieth century, in *Les fonctions mentales dans les sociétés inférieures* (1910), then *La mentalité primitive* (1922) and *L'âme primitive* (1927),[16] the philosopher Lucien Lévy-Bruhl endeavors to make ethnology a science of the radically other, of that which is totally foreign to "us," thus undermining the basis for the foundational claim of humanism: "nothing human is foreign to me." The exploration of differences, of *being otherwise*, seems with him to cease paying tribute to *sameness*. His initial position can be found in his philosophical practice. After a few works in the history of philosophy (including the monumental *La Philosophie*

d'Auguste Comte, 1900), Lévy-Bruhl publishes *La morale et la science des mœurs* (1903).[17] It becomes the occasion for a lively debate between the author, who insists on the idea of a science that will study "mores" (*mœurs*) as "desubjectivized" social reality, and those whom he indicates, in the preface to the 1927 edition of the book, hold to a morality that would be universal because they are accustomed to speculating on "man in general." Against the idea of "man in general," holding that the idea of morality is given first of all in its specific social reality and diversity rests on the observation that human cultural formations have produced, across time and space, very different institutions.

Given this, it is natural enough that Lévy-Bruhl came to wonder about a differentiated theory of human knowledge: if humans are so different and the institutions they create for themselves equally so, why would they not be equally different in their mental structures and procedures? Why continue to believe "in the unity and identity of the human mind"?[18] Lévy-Bruhl is perfectly aware that his intrusion of philosophy in the universe of anthropology, principally English anthropology, constitutes a paradigmatic rupture:

[. . .] when the theorists of animism describe the customs, the beliefs and the institutions in place in primitive societies, they take it for granted that

mental functions are everywhere the same and that, if we were in the primitives' place, our mind being what it currently is, we would think and act like they do. I start, however, from precisely the opposite hypothesis. I posit that to think and act like they do such that their societies are built on the institutions we observe among them, it is necessary that their mind be not oriented like ours, that the content and framework of their experience not coincide completely with ours, and that, as a result, we must expend a very taxing amount of effort to enter into their way of thinking or feeling.[19]

We will make two remarks on this assertion by Lévy-Bruhl of the existence of a form of thinking and feeling that are characteristic of a primitive mentality. The first concerns the identification it sets up of all "primitives" in the space of the same radical alterity with regard to "us," i.e., Europe. The Europe of Lévy-Bruhl that looks at others with the gaze of the ethnologist does not ask them to disclose their particular identities but to indicate their *difference*, which is, from his point of view, the same for all of them. Regarding this automatic lack of distinction for which he has been reproached by many, including the rigorous Marcel Mauss,[20] Lévy-Bruhl explains (in the foreword to his *Le surnaturel et la nature dans la*

mentalité primitive (1931) that all he had done was retain from among the specific characteristics of each of the societies thus put together the traits that are common to them all.[21] This quick answer, which is unafraid of the possibility that it begs the question, ultimately reveals that the primary concern of the author is not ethnological method itself. The true answer is in the philosophical premise that led the 53-year-old historian of philosophy to become interested in "primitives" in order to illustrate his already constructed theses. This true answer, behind the one he gave to the critics questioning his generalizations, is that, after all, reason's *other* could only be the *same*.

The second remark to be made on Lévy-Bruhl's cognitive dualism is that it destroys the notion of humanity. If we cannot speak of the human mind in the singular, can we continue to speak of humanity in the singular? Is not the latter at this point nothing more than, to use the expression of the cultural separatist Alain de Benoist, a pure "zoological summation" of radical differences?[22] If human identity, as demonstrated by the use of language, the transmission of a cultural heritage, or the creation of institutions is, of course, recognized, it remains no less the case that, for Lévy-Bruhl, the difference in structure between human societies and thus between their "mentalities" can be considered analogous to the way in which "invertebrate animals differ from vertebrates."[23]

Thus Lévy-Bruhl breaks with the cognitive monism that ethnology until that point had never really put into question and presents "under an old name, the primitive, this new and unknown thing, a veritable enigma to be deciphered: primitive mentality."[24] Indeed, this *alternative* way of knowing cannot help but be an "enigma." How could logical intelligence know and translate into its language that with which it is incommensurable?[25] Lévy-Bruhl recognizes this difficulty even in his choice of the concept of the prelogical to characterize primitive mentality. The concept is more easily defined by what it is not than what it is: prelogical does not mean antilogical or alogical, and neither is it a "pre-logic" that would be like the childhood and foreshadowing of mature logic. The key to it is the "law of participation" that governs it. It is this law which facilitates understanding of the apparent indifference of the "primitives" to the principle of non-contradiction, which is the reason they can produce an utterance like *Bororos are araras*—the famous example of the participation of the Bororo people in their totem, the arara parrot—with no concern for contradiction: in their mystic (non-rational), collective (non-individual) mentality, dominated by "emotive associations and preconceived links"[26] (and not by logic and experience), a natural consubstantiality exists between humans and parrots.

After many modifications, Lévy-Bruhl will finally declare that this other logic, this "alterna-logic" as we might call it, is simply the sign of "mystic" thinking and feeling, which is often—but not always—"indifferent" to the principle of non-contradiction. In the end, the difficulties of giving substance to a true cognitive dualism will lead him to the final recantation in his posthumous *Les Carnets de Lucien Lévy-Bruhl* (1939),[27] in which he admits that what classical logic called "the laws of thought"—the logical principles of identity, non-contradiction and the excluded middle—structure the human mind in general.

ART AS KNOWLEDGE

One of the critiques often directed at Senghor consists of a reproach for taking up for himself the Lévy-Bruhlian philosophy of primitive mentality, the pre-*Notebooks* version no less, in order to construct an *alternative* African theory of knowledge resting on what the author of *Primitive Mentality* had called the "law of participation."[28] This criticism, which is legitimized for example, by the vocabulary of "participative reason" that Senghor sometimes borrows, remains nevertheless incomplete and thus false inasmuch as one does not work to specify that the poet's thought is an oscillation between Lévy-Bruhl and Bergson—an oscillation that does not imply inconstancy

and inconsistency since, once again, the source of direction is the philosophy of African art.

If one wants to make his theory of African thinking and feeling simply a positive turn on the notion of "primitive mentality," one must be equally able to account for what he says of Lévy-Bruhl's thesis in an unequivocal refutation that appears in his earliest writings. In one of the texts where the dialectical tension that runs through his philosophy is most evident, "Vues sur l'Afrique noire ou Assimiler, non être assimilés," Senghor opposes in one move both colonial assimilationism that negates all "indigenous" culture, affirming that there exists an African "originality" to be respected; and "anti-assimilationism" that forbids any real association in a "community" of citizens, for Senghor sees in this a philosophy of separateness and thus inequality. The figure who represents this anti-assimilationist philosophy is, for him, Lévy-Bruhl:

> We have a different temperament, a different soul, certainly. But are the differences not in the ratio between elements more than in their nature? Underneath the differences, are there not more essential similarities? Above all, is *reason* not *identical* among men? I do not believe in "prelogical mentality." The mind cannot be prelogical, and even less alogical.[29]

This is indeed clear and invites us to ask questions about the distinction Senghor sets up between a difference in *ratio* and the difference in *nature* implied by the concept of the prelogical. The answer is in Bergson, who expresses the human ideal that can be ascribed to the "total man." Wondering about the meaning of evolution in light of the appearance of consciousness among humans, Bergson writes:

Consciousness, in man, is pre-eminently intellect. It might have been, it ought, so it seems, to have been also intuition. Intuition and intellect represent two opposite directions of the work of consciousness: intuition goes in the very direction of life, intellect goes in the inverse direction, and thus finds itself naturally in accordance with the movement of matter. A complete and perfect humanity would be that in which these two forms of conscious activity should attain their full development. And, between this humanity and ours, we may conceive any number of possible stages, corresponding to all the degrees imaginable of intelligence and of intuition. In this lies the part of contingency in the mental structure of our species. A different evolution might have led to a humanity either more intellectual still or more intuitive. In the humanity of which we are

a part, intuition is, in fact, almost completely sacri-
ficed to intellect. It seems that to conquer matter,
and to reconquer its own self, consciousness has had
to exhaust the best part of its power. This conquest,
in the particular conditions in which it has been ac-
complished, has required that consciousness should
adapt itself to the habits of matter and concentrate all
its attention on them, in fact determine itself more
especially as intellect. Intuition is there, however,
but vague and above all discontinuous. It is a lamp
almost extinguished, which only glimmers now and
then, for a few moments at most. But it glimmers
wherever a vital interest is at stake. On our person-
ality, on our liberty, on the place we occupy in the
whole of nature, on our origin and perhaps also on
our destiny, it throws a light feeble and vacillating,
but which none the less pierces the darkness of the
night in which the intellect leaves us.[30]

This text needed to be quoted at such length because it is
important for understanding why Senghor is Bergsonian
rather than Lévy-Bruhlian. Although we can compare
Lévy-Bruhl's philosophy to that of Bergson (who gradu-
ated the same year as him from the École normale supéri-
eure) in that they both explore a non-logical approach to
reality, a way of understanding things that is not analytic

and which does not begin by separating them *partes extra partes*, the above-quoted passage marks a fundamental difference between their projects. Where the author of *Primitive Mentality* envisions humanities separated according to the structure of their minds, the author of *Creative Evolution* envisions the becoming of a humanity that, overcoming its inner separation, accomplishes itself in the equality and "full development" of the two forms of its conscious activity.

With the way of thinking which obeys the law of participation, Lévy-Bruhl thought it possible to make sense of that which, among the humanity composed of "inferior societies," *takes the place* of the logical cognitive procedures that we expect from European individuals. What Bergson says, on the other hand, is that the human (the last to be born in what Teilhard de Chardin calls "cosmogenesis") will discover that he is a bridge towards the "complete and perfect" human he is called to become: equally intelligent and intuitive. When Bergson says "we" in "the humanity of which we are a part," he is making a comparison with this ideal humanity. This "we" that is thus compared includes everyone: this two-directional conscious activity is the same in all. For the moment, Bergson says, we are an unbalanced humanity led by intelligence in which intuition does not shine all of the light it is capable of in order to illuminate our human destination.

La Revue du Monde Noir, founded at the beginning of the 1930s by the sisters Paulette and Jane Nardal as a voice in French and English of a "Pan-Negro" intellectual movement in Paris (the first issue appeared in Fall 1931), was, evidently, an essential source of inspiration for Senghor. "The list of contributors to the *Revue*," writes Hymans, "is a directory of the men whose ideas, absorbed and reworked by Senghor, gave birth to his theory of *négritude*." In particular, a short piece by his Senegalese friend Pierre Baye-Salzmann called "An Opinion on Negro Art" along with a longer one entitled "Negro Art, Its Inspiration and Contribution to [the] Occident" were very certainly meditated upon over a long period of time by Senghor.[31] At the end of the second article, Baye-Salzmann writes:

> In 1919, at the "Comédie des Champs-Elysées," Paul Guillaume, who cannot be denied a vast competency in art, already adduced the following precept: "The mind of modern man and woman must be Negro." That was perhaps going rather too far in the way of enthusiasm...Nevertheless, it is a fact that [the West] can, without disowning itself, find in black aesthetics a source of original inspiration and a powerful factor of renovation.[32]

A becoming-Negro of modern intelligence? This statement by the art critic Guillaume does not make sense,

first of all, unless related to the Bergsonian atmosphere in which French letters bathed at the time; it indicates faith in a becoming-human that will make a proper place, beside an intelligence which separates in order to weld together, for an intelligence that takes things together as a whole and perceives "a unity resembling that of a phrase in a melody."[33] The statement makes sense, secondly, if this other intelligence, the synthetic one, is associated more closely with African peoples, but for this sole reason (and this is the third condition for Guillaume's "precept" to have meaning): that their aesthetics manifest it to the highest point. "More closely" does not mean "exclusively" nor does it mean "to the exclusion of the other intelligence." It simply means, to put it in Bergson's language, that among certain human populations, in a domain where "a vital interest is at stake," the light of intuition makes itself more intense and more continuous. This domain is art.

Now is the time to return to Senghor's formula that caused such scandal: emotion is Negro as reason is Hellenic. In the details of his writings over the five decades following its first enunciation, Senghor's explanation of what he *really* meant to say oscillates between recantation and going on the offensive. One can find plenty of quotations in his work going in one way or the other. I wish to emphasize, nevertheless, that the truth in Senghor's thought (if we insist on reducing it to this formula), once we take

a step back and relate it to the initial intuition from which it is born, is this: in African art where "a vital interest is at stake" (and this is its major characteristic), emotion or intuition or even *con-naissance* (concepts which for Senghor translate the same non-analytic approach to reality) attain an intensity that reminds the human of the promise of a more complete humanity. Let us reiterate that this formula, before being a theory of African thinking and feeling, expresses first of all a philosophy of African art. Better, or more precisely: it is only a theory of African knowing because it is a theory of African creating, art being in itself knowledge of reality.[34]

In saying that art is the ultimate manifestation of intuitive knowledge, Senghor is more Bergsonian than ever. What Bergson says about intuition as an aesthetic faculty is once again illuminating here:

> Intelligence, by means of science, which is its work, will deliver up to us more and more completely the secret of physical operations; of life it brings us, and moreover only claims to bring us, a translation in terms of inertia. It goes all around life, taking from outside the greatest possible number of views of it, drawing it into itself instead of entering into it. But it is to the very inwardness of life that *intuition* leads us—by intuition I mean instinct that has become

disinterested, self-conscious, capable of reflecting upon its object and of enlarging it indefinitely.

That an effort of this kind is not impossible, is proved by the existence in man of an aesthetic faculty along with normal perception. Our eye perceives the features of the living being, merely as assembled, not as mutually organized. The intention of life, the simple movement that runs through the lines, that binds them together and gives them significance, escapes it. This intention is just what the artist tries to regain, in placing himself back within the object by a kind of sympathy, in breaking down, by an effort of intuition, the barrier that space puts up between him and his model. It is true that this aesthetic intuition, like external perception, is only attained by the individual... But, in default of knowledge properly so called, reserved to pure intelligence, intuition may enable us to grasp what it is that intelligence fails to give us and indicate the means of supplementing it.[35]

This text is usefully placed in relation to this reflection by Baye-Salzmann:

[. . .] our inmost tragedy, our being torn apart between the two poles of life: the feeling of our duration and our determination not to die, even through

the medium of some participation in eternal cre-
ation. The arts, when we come to think it over, have
no other source.

But, through that medium, each race makes use
of a certain process as its own expression. Whereas
Western man for instance, denying the total annihi-
lation of self into God—the term of Palingenesis, the
Oriental creed—takes the creative intelligence as a
motive to free himself from instinct and its torments,
the Negro chooses intuitive sensibility as his object
and demands of it the religious and poetical expres-
sion of the problem of after-life and its many inter-
rogations. From this comes the latent dynamism of
his art, the direct outcome of pure mystic passion.[36]

Let us begin by considering the aspects of Bergson's
text which are essential for understanding Senghor's artistic
theory of knowledge, according to which "art is...a means
of knowledge."[37] If intelligence produces the science of the
physical world, says Bergson, it fails to grasp the vital ele-
ment because it inevitably misses, by its very nature, the
possibility of an *alternative* relation to the object: one
which consists in entering into "sympathy" with it, entering
"into it" in order to coincide with it, moving beyond the
face-to-face of subject and object in order to become situ-
ated within the vital element— in order, as Senghor says,

to "know [the world] vitally."[38] The faculty that operates in this way is intuition. It has, at the end, nothing to do with an ineffable occult power. Its mystery is nothing other than that of the creation of a work of art, the condition of which is the overcoming of the separation that space imposes: thus does the aesthetic faculty produce the unity of elements that mutually interpenetrate in the work of art in order to create what Bell calls a "significant form,"[39] through which the movement of life, vital rhythm itself, gives itself to be felt *uno intuitu* [in a single intuition].

What the Baye-Salzmann passage adds to this presentation of the aesthetic faculty as a cognitive one is to make it a mode of approach to reality privileged by a "race." Why move in this way from the individual artist and his aesthetic solution to the problem he faces to the collectivity of which he is a part, especially his race? Such a move is, clearly, no longer Bergsonian. It is made possible by means of an ethnologization, so to speak, of Bergsonian theses. This in turn can be justified by the place that art occupies in African societies according to Senghor. It is social, he says, first in the sense that, even if there are professional artists, "all manifestations of art are collective, made for all with the participation of all."[40] Second, it is social in the sense that "the artisan-poet is situated and engages, along with himself, *his* ethnic group, *his* history, *his* geography" in the creation of "significant forms" that *give life* to the

socio-religious ceremonies in which the object he causes
to be fulfill their function.[41] The problem the artist faces
is thus not his alone; it is also the collective's and this is
why, even though he is the sole *inventor* of the work, the
author of the work is the community who *accomplishes* it.
This is, at least, the reason Senghor thinks it is possible to
slide from the world in which the artist lives as he creates,
led by emotion (intuition), to a vision of a collective world
and a particularly African "knowing" to which the art of
the black continent gives witness.

When Senghor, following Sartre, speaks of emotion
as "an abrupt drop of consciousness into the world of
magic,"[42] it is still first and foremost within the frame-
work of his philosophy of African art: this "turmoil of
consciousness" is the path "that descends from the world
of things that are visible and clear to the world in which
they are invisible and confused, from the world of static
appearances to the world of dynamic realities, from the
world of eye-reason to the world of embrace-reason."[43] In
art, the "participation" that reigns in the magical world
is defined in opposition to "imitation" or mimesis, as in
the statement by historian and art critic, Pierre Schneider,
quoted by Senghor:

> Art grounded in intelligence identifies things; art
> grounded in emotion identifies with things. The

work is no longer a discourse on a subject but a dialogue with it. Imitation gives way to participation.[44]

Transferred from the domain of art to that of knowledge, "participation" becomes, for Senghor, the non-Aristotelian logic called for by the new developments in contemporary science which thus testify that the approach that does not separate is a true path of knowledge.

It is indeed true that the modern science of quantum physics, non-Euclidean geometry, wave mechanics, relativity, etc., requires the transformation of the mental categories we use to think about reality.[45] They profoundly put in question what Nietzsche called scientific *"faitalisme"* (factalism), the belief in the possibility of separating and isolating the facts to be studied from one's separated position. Senghor notes with all those who reflect on the "new scientific spirit" that the classical binary logic of here and there, of yes and no, has become much too narrow for the contemporary episteme. Thus Senghor speaks of the "triumph of the new epistemology" that, according to him, from within the domain of analytic knowing *as well*, calls hereafter for the development and participation of *alternative* knowledge.

With respect to this new epistemology, he shares the views of philosopher, art critic and literary critic Gaetan Picon, according to whom the placing in question of

object realism by new science signifies the call for another approach to reality. Thus, in a paper written in 1960 for a Youth Seminar of the "Party of the African Federation" (which had just been created), Senghor quotes the following lines from Picon:

> We are witnessing the general ebb of the idea of objectivity. Everywhere we find the researcher implicated in his research and able to reveal something only by hiding it. The lamp of knowledge is no longer the inalterable light that is put upon the object without touching it or being touched by it: it is a fulguration born of their embrace, the flash of light of contact, a participation, a communion. Modern philosophy would be *experience*, the lived identity of knowledge and the known, the lived and the thought, the lived and the real.[46]

We may note here that the words Picon uses, above all the participatory character of an *alternative* knowing, are also those that a Lévy-Bruhlian ethnology could use to speak of the irremediably "mystic" approach that the "primitive mentality" has to things. It is, in fact, this lexical *identity* that leads Senghor to carry out his *identification* of the "new scientific spirit" with *con-naissance*, i.e. *la naissance avec et à* (birth with and to), the exemplary

approach to things which he does not hesitate to call "Negro African."[47]

There is a real tension in Senghor's thought between Lévy-Bruhl's type of cognitive dualism and the type found in Bergson's philosophy. He often speaks, like the former, of an "African episteme," but to this is always added or specified, firstly, that this is the same thing as the way in which art "thinks" the world and, secondly, that the identity of human thought is everywhere established beyond what Senghor calls "preferences" for this or that form or expression.[48] Ultimately, his position is indeed on the side of Bergson: there is a symbiosis to come, which is also a sort of return to the pre-Aristotelian *logos* that shall settle the score with the lone *ratio*.

We should note that, in the end, this was also the final position of the late Lévy-Bruhl. The year of his centenary, 1957, gave the *Revue Philosophique* (of which he was the chief editor for more than 20 years) an opportunity to revisit and rethink, in a special issue,[49] his work and the truth within it of a humanism more integrated and integral than the theses on the existence of a *primitive mentality* would cause one to think. This does not at all require making excessive demands on the texts; it suffices to be attentive to what Lévy-Bruhl himself says of his own approach even before the recantation of the posthumous *Notebooks*. In his correspondence, he recognized that he overstated the

case in his contrasts between the mystical and the ratio-
nal, claiming that it was for the purpose of making the
difference easier to perceive.[50] Most significantly, he de-
constructed on his own the notion that mentalities could
divide humanity.[51] His final vision was ultimately that every
human is a fundamental hybrid in which different types of
mentalities meet. In the end, as Emmanuel Levinas con-
cluded when measuring the importance of Lévy-Bruhl's
thought for contemporary philosophy, when we consider
this thought beyond the radical differentiations to which it
cannot be reduced, "difference...separates two depths of
the soul rather than two souls."[52]

More specifically, in unpublished notes cited by his
friend Pierre-Maxime Schuhl, Lévy-Bruhl arrives at the
completion of his reversal when he writes that while it
is necessary to "continue the efforts of reason to under-
stand and master the world," it is necessary "at the same
time to recognize that without the foundation of primi-
tive mentality (participation), we will not have invention,
poetry, not even science."[53] "Not even science," he insists:
he thus managed to consider, in his last statements, the
fact that, on one hand, there does not exist anything like a
uniquely participatory mentality that does without logical
principles and takes the place of intelligence for a particu-
lar humanity, and, on the other hand, that there does not
exist a human intelligence that is nothing but analytic and

that we can isolate in its purity and keep disengaged from all emotion. Moreover, to believe that the production of science is a function of such disengagement would be to think like Immanel Kant's dove who believed it would fly much better without the resistance of air. Notes written by Lévy-Bruhl for lectures near the end of his life show the direction in which his thought was headed at that time: without the *reason-that-does-not- separate*, which is constitutive of human reality everywhere, there would be no science. For—and we find him in agreement with Senghor here—it is a "way of apprehending the world," as Sartre will say of emotion; it is a way of seeing the world as a "non-instrumental totality" that is as indispensable to science as it is to art or creation.[54]

Eventually, at the end of the journey which had led him to ethnology for the sole purpose of better confirming the philosophical preconception of a radical separation between "us" and "them," Lévy-Bruhl ended up finding the real lesson of this human science *par excellence*:

Achieving depth means plunging into the Other to discover what unites me with him and what he reveals to me of myself. Is that not the very foundation as well as the goal of our ethnological research? *Je est un autre* ("I is an Other" [Rimbaud]) would cease to remain a joke or an unsolvable riddle if one

discovers *oneself in the Other* or, in other words, if the Other as Other turns out to be the same as me in his very difference.[55]

For his part, Senghor always considered ethnology as this humanism of encounter, as victory over separation.

CONVERGENCE

Each civilization has thought at the level
of the universal.

Léopold Sédar Senghor[1]

ON 22 SEPTEMBER 1968, German writer
Günter Grass wrote a letter to Senghor, who,
on the same day, was given the Peace Prize of
the German Book Trade. It drew his attention
to the African "genocide" that—according to
Grass and a number of German civil-society
organizations who joined his appeal—the war
being fought by Nigeria against the secessionist
Biafra was in danger of becoming. If the letter
obviously addressed itself to Senghor as a head
of state since it is in this capacity that he was
being asked to intervene, the author also insisted
on saying it was addressed in the first place to
Senghor the writer, which we may take to mean
a man of letters and thus a man of conscience.

Senghor therefore replied as such, as a "man accustomed
to dreaming," in the words of Mallarmé.[2] And if he prom-
ised to do what he diplomatically could about the Nigerian
Civil War, it is precisely as a man who "dreams" that he
evoked the true and lasting solutions which, for him, were
the accomplishment of African unity and, beyond that,
a world truly one, in which differences would be woven
together. "In this time of the totalization of Planet Earth,
as we await its socialization..." he writes in his response
to Grass.[3] I shall translate this into today's terms: in this
time of globalization, as we await dialogue and a true con-
vergence of cultures...

For what we call globalization today is not a dialogue
of cultures. Even if it is the result of the prodigious de-
velopment of the means whereby humans with different
perspectives can now communicate with each other, glo-
balization does not promote such a dialogue. In many
respects, it is even the opposite. The forces upon which
it is based are completely satisfied with the simple jux-
taposition of cultures that shall remain exterior to one
another, provided that cultural industry manages to offer
it a homogenous, undifferentiated terrain for expansion
and does not confront it with the discourse of necessary
diversity (which it will not understand). For this form of
globalization, which is identified with the project of the
World Trade Organization (WTO), there is the cultural

product on the one side and its potential consumers on the other. The idea is that freedom, understood as the free access of the product to the consumer, will not be interfered with. That cultural creations not supported by powerful financial entities hardly find a place in this market is in the natural, i.e. Darwinian order of things. We can always find another place for them or they can exist as "curiosities." Just as for poverty there is philanthropy, there can be a few reserved spaces for what minoritized cultures have to say about the human to other humans.

To stand up to this steamroller, there is, by contrast, what we might call *UNESCO globality*.[4] It is based on the idea that cultural communication in its entirety is not this arrow from the product to the consumer within an isotopic space but, rather, *interlocution*, of which homogenization would constitute a negation. The issue, then, is to ensure that each cultural voice, i.e. each particular perspective on the universal human condition, is heard and recognized in a real polyphony, a true dialogue.

Homogenization can take on two different but related faces: imperial negation or commercial crushing. The first corresponds to the face of a Europe that has thought itself invested by its unique telos with the mission of remaking the world in its image. Thus Edmund Husserl wrote that it was urgent that India Europeanize itself as best and as fast as possible while Europe itself,

quite obviously, unless it wished to become unselfcon-
scious, had no reason to Indianize itself in any way.[5]
Césaire has said, tersely and accurately (as always): this
Europe does not dialogue, it soliloquizes. The second
face is that of powerful cultural industries, such as cin-
ema or music, which apply themselves to creating a com-
mercial void outside themselves.

The goal in whose name it is necessary to oppose uni-
fication by globalization and thus promote interlocution
and dialogue is diversity, certainly, but diversity for the
sake of true unity. It is unity that is at stake, unity whose
true nature is to be made of additions and contributions
rather than subtractions and evictions. This philosophy of
dialogue can be expressed as follows:

> Before the recent disturbances which have woken up
> the earth, its peoples hardly lived on more than a
> surface level. A world of energies remained dormant
> in each of them. Indeed, it is these still hidden pow-
> ers, I imagine, at the base of every natural human
> unity in Europe, Asia and everywhere, that are be-
> coming agitated and that want to come to light at
> this moment; not for the sake, ultimately, of oppos-
> ing and devouring each other but joining and cross-
> fertilizing each other. Fully conscious nations are
> required for a total earth.[6]

One must surely recognize in the above quote the voice of Teilhard de Chardin. Join and cross-fertilize one another, he says; taking the opposite view from Husserl, this philosopher of a post-imperial world invites India and Europe to a real encounter. Bring about a "total earth": this magnificent phrase can serve as a rallying cry to those who are working towards an alternative globalization and it also gives content to what has been referred to as "UNESCO globality." Senghor enthusiastically cites these lines from Teilhard de Chardin as announcing "the 'true union' which does not confuse but, rather, differentiates while mutually enriching" (a reference to Teilhard de Chardin's statement that union differentiates).[7] He also, for the same reasons, celebrates UNESCO as the perfect setting for the Dialogue of Cultures. When he paid tribute to the mission of this institution as he and an independent Senegal officially received UNESCO on 20 April 1961, he did much more than simply fulfill a diplomatic duty.[8] In his speech he recalls, first of all, that as a *French* politician and member of the French delegation, he fought from the beginning "for the erection at the heart of Paris" of UNESCO. He then indicates that this institution is precious for a world emerging from decolonizations (disturbances which have woken up the earth) as it has understood Teilhard de Chardin's idea that "the Civilization of the Universal, on pain of not being at all, will be the

collective task of all peoples, races, and continents—of all particular civilizations."[9]

What trajectory led Senghor to this moment? How did his thought come to be a philosophy of dialogue and convergence?

BEING AN INTERLOCUTOR

To answer this question, it is necessary to first revisit the youthful years of this man who often recalled the importance for the genesis of his philosophy of the education he received from the Holy Ghost Fathers, first at the Catholic mission school at Ngasobil from 1914 to 1922 and then at the Libermann seminary that had just been created in Dakar in 1923. Every Senghor biography has emphasized, in particular, the profound influence exercised on him by Father Albert Lalouse, the first headmaster of the seminary.[10] This influence is to be measured as much by the spirit of confrontation that Father Lalouse's calm colonial racism developed in his young pupil as by the quality of his teaching. Here is how Senghor describes the Spiritan father's attitude and his own reaction to it:

> He placed much emphasis on our Negro imperfections and denounced our backwardness on the level of civilization. As I had had a bourgeois and

even aristocratic upbringing, I reacted even then by asserting that we too had a civilization...Father Lalouse often reproached us for our verbalism and lack of method. From that moment on, I understood the importance of method and the value of words.[11]

The Spiritan father could not understand why this young boy manifested any pride in his origins and how he could have the feeling of belonging to a civilization as valuable as any other. He could not understand why Senghor, who spontaneously became the spokesperson for the other students, opposed head-on his civilizing certainties. He thus interpreted the stubborn questioning of his project of making "black-skinned Frenchmen" of his students as a spirit of disobedience and it is, no doubt, with total sincerity—"with firm kindness," says Senghor himself—that he decided to bar Senghor's path to the priesthood, judging that this was clearly not his proper vocation.[12]

It is a truth taught to us by psychology that confrontation often has the profound meaning of being a call to dialogue. For the first condition of dialogue, that which makes it even possible, is the existence of interlocutors who recognize each other as such, who pay *attention* to each other. What colonial situations by definition forbid is precisely this situation of interlocution. Attention to one another is impossible and what the young Senghor asked for

without really knowing it was, for Father Lalouse, whatever his kindness and whatever benevolent diligence he put into his mission and priesthood, completely inaudible.

Later, Senghor would say of this confrontation with Father Lalouse that it taught him, without the concept itself, the emotional reality of Negritude, i.e. the affirmation of self as a potential participant in a dialogue, a rightful subject in an interlocutory situation. Dialogue always happens, ultimately, between individuals: it is through them that cultures speak with each other. Or, to put it more precisely, cultures are in the background of signs and words that are exchanged, constituting the horizon of inter-individual dialogue.[13]

In the end, Senghor never ceased to pursue the dialogue that never took place, that could not have taken place in such a situation of asymmetry with Father Lalouse. The seminal event of his speech in 1937 at the Chamber of Commerce in front of the whole Dakar high colonial society can be read as a reprise of that confrontation. The child was now a man; the student had now been a teacher and an *agrégé* in grammar for two years; he had met Césaire and, with him, devoured ethnological discourse (above all that of Frobenius) and had thereby discovered what he had been trying to say to Father Lalouse without having had the means to do so at that time. Were the representatives of the colonial administration who

came in total benevolence to applaud him, all these Father Lalouses who had shown up and who were seated in the first rows of a Chamber of Commerce full to bursting with an audience come to hear the first African *agrégé*, now in a dialogical situation? Could they, in listening to him, hear him as an *interlocutor*?

Among Senghor's biographers, it is Vaillant who underlines most insistently the profound meaning of this moment, his first public speech.[14] She indicates the circumstances of the event: when he returns to Senegal for the first time in many years for ethno-linguistic fieldwork, Senghor is invited by the Franco-Senegalese Friendship Society to give a speech at the recently built Chamber of Commerce. This is a way of presenting to the public the Serer *agrégé* whom the Inspector General of the Ministry of Education declared to be "truly French" and whom Governor General De Coppet invited to dinner on the eve of the talk. Vaillant describes well the elite of the colonial administration placed in the first rows while the crowd of students and other curious Africans pile up at the back of the room or even gather outside, hoping to catch a glimpse of the one who has become a symbol giving true meaning to the colonial mission in which France was invested. All that people are expecting of him, really, is that he will give a speech of ceremonial value, speaking but representing nothing but the possibility, of which he

is the proof, that an African can "evolve" so totally as to reach the pinnacle of French culture.

Without raising his voice, presenting himself from the outset as a peasant from the Sine region of Senegal, Senghor completely changes the rules of the game, forcing the audience to listen to an interlocutor and pay *attention* to a real *content*. He forces them to pay attention to the content he gives to the concept he is then using of "Afro-French" or, beyond that, the "New Negro" (which he adopts following the black American writers of the Harlem Renaissance movement); to the bilingualism he advocates, bilingualism in French and an African language (Mandinka, Hausa, Yoruba, Fulani, Wolof, etc.), in order to allow an "integral expression of the New Negro"; to the mission of "intellectuals" to "restore *black values* in their truth and in their excellence."[15] The words of African American writer Claude McKay with whom Senghor concludes his talk constitute an eloquent illustration of what "being an interlocutor" means: "Diving down to the roots of our race and building on our deep reserves is not returning to a savage state: it is culture itself."[16]

Vaillant tells us that the speech was met with a certain amazement that revealed itself in murmurs, even if the colonial authorities overcame their consternation and chose to applaud and then publish the talk in the newspapers (without commentary). Senghor, writes Vaillant, had

thus "planted the seed for a new development of culture, even though conditions were as yet unfavorable for its growth."[17] We can understand this new cultural development as nothing other than the possibility of a dialogue of civilizations whose "conditions of growth" have, even today, not yet been entirely brought together.

Can one of the religions that proclaim themselves universalist (i.e. those called "Abrahamic") dialogue with those who do not? Can it pay attention to what a foreign culture has that is vital and worthy of attention? Such questions were also present in the absence of dialogue against which Senghor struggled as a young student at the seminary. They concern the way in which one should understand the famous words of the founder of the Congregation of the Holy Spirit and the Immaculate Heart of Mary (whose name the seminary bore), Father François Libermann: "Make yourselves Negroes among the Negroes, in order to win them to Jesus Christ." How should this instruction of Libermann's to his missionaries in Dakar and Gabon, in a letter of 19 November 1847, be understood? In particular, what meaning does this command give to being-Negro?

Here, first of all, is what Senghor, recalling his youth, at the end of his active life, wrote concerning the Father's directive in the preface to *Libermann 1802–1852: Une pensée et une mystique missionnaires* (1988):

It was during the 1920s, while I was a student at the Libermann seminary in Dakar, that I began to reflect on the thought of the founder of the Congregation of the Holy Ghost and the Immaculate Heart of Mary. Often, indeed, we were made to meditate upon what was presented to us as a single sentence but a truly great one. I do not know why I did not retain "Make yourselves Negroes with the Negroes, in order to win them to Jesus Christ" but instead "Be Negroes...." Upon reflection it is no doubt because, as a Negro, I was more sensitive to the results and already convinced, whereas European missionaries, particularly the French, still needed to be convinced of the effort to change, required for transforming themselves into "Negroes."

Nevertheless, before going any further, we need to cite the famous phrase in its entirety: "Do not judge at the first glance, based on what you have seen in Europe, what you are used to in Europe; strip yourselves of Europe, its customs, its spirit; make yourselves Negroes with the Negroes in order to form them as they ought to be, but not in the ways of Europe—leave to them what belongs to them; make yourselves to them what servants must make themselves to their masters, to the customs, style and habits of their masters; do this to perfect them, sanctify

them, pull them out of baseness and make of them, little by little, over time, a people of God. This is what St. Paul calls making oneself all things to all people, in order to win them all to Jesus Christ."[18]

We can see in this more complete quote from the Spiritan Father—behind the unavoidable paternalism of someone unable to doubt having the Truth which those who do not yet know it must be made to hear—concern for what does, in fact, constitute a dialogue. The meaning of his admonition to his missionaries is that, to enter into interlocution, one must know how to decenter oneself, to be attentive to the other and—against the temptation to assimilate him or her to oneself—to respect what it is that the other has to be, his or her "*to ti en einai*" ("that which something has to become").

At the end of his preface, Senghor also wants to see in Libermann's admonition a prefiguring of the Church's current thoughts concerning the necessity of an "inculturation of the Gospel in African culture," recognized as valuable and thus equal to all others. The inculturation of the Christian Message—its reception by Africans but from within their Africanity—was, from the beginning, a matter of great importance for Senghor. We can affirm that his thought as a whole centered on this question and that it was, though no doubt confusedly, the origin of

the fatal misunderstanding that had to take place between the young boy that he was and the Father Lalouse he would later call a "saint."[19] It is why, ever since he and his schoolmates were first made to meditate upon it, he always wanted to read more into the founder of the Congregation of the Holy Spirit's "great sentence" than he found there or than the missionaries to whom it was addressed could understand: the idea that African civilization was equal to all others, European in particular. He himself emphasized, in connection to this, how interesting it is that he always misunderstood to some degree Libermann's directive, making it more sympathetic to the colonized Africans than it was in reality.

We can think of the period during which Senghor experienced a loss of faith as the result of his impatience to see the Catholic Church respect Africanity and recognize the necessity of inculturation. It is also linked to his entry into the world of socialist ideas and activism, to which he was introduced during his studies at the Lycée Louis le Grand (where he was doing preparatory classes for entry into the École normale supérieure) by his friend Georges Pompidou. Jacqueline Sorel presented this aspect of his life:

> At 25, if one is not on the left, one has no heart. His friend Georges Pompidou led him into socialist circles. He made him read the articles of Léon Blum in *Le Populaire*. Senghor joined LAURS, the Ligue

d'Action Universitaire républicaine et socialiste [the
Republican and Socialist University Action League].
There he met Edgar Faure and Pierre Mendès
France, diligent activists like himself.[20]

As for Senghor, he presents his development and his state
of mind when, after the Second World War, he became
active in politics, in this way:

> Thus, as a young Socialist member of Parliament
> (young by election, not age), I threw myself, with a
> passion that I hoped was lucid, into a re-examination
> of Marx and Engels. Ideas, and even more the scandal
> that was the life of the bourgeois Catholic, had made
> me lose my faith some years before. Catholicism, at
> least as it was practiced in France, could not suit the
> Negro African I was: alienated and thus humiliated.
> Once again, let me be clear, what was in question
> was not myself as a person, which had formed friend-
> ships as a shelter, but myself as one of the colonized,
> whose Being identified with Negritude. I sought,
> then, in the years after the Liberation, my own lib-
> eration, in fear and trembling. For beyond the po-
> litical or even the economic, this was a matter of
> spiritual liberation: a true search. This was a matter
> of finding, through and by means of my Negritude,
> my identity as a man. This was a matter, to put it

simply, of being no longer a consumer but rather a producer of civilization: the only way, in the end, that there was to *be*.[21]

Senghor remained a socialist all his life, even if he did not fail to insist again and again on the fact that the foundational texts of "socialism" needed to be submitted by Africans to a re-reading special to them.[22] He would never be a "materialist" if we understand by that someone who posits the existence of a dualism of material and spirit with the ontological and logical primacy belonging to the former. Upset with the Church rather than atheist, socialist but profoundly spiritual, an engaged militant in the defense and illustration of African values and more than ever in the search for the self, Senghor needed a general cosmology that would allow him to think about God, about different cultures in their equivalence, dialogue and convergence at the "meeting place of give and take" (Césaire's expression), and about socialism together. It is this cosmology that he finds in his encounter with the thought of Teilhard de Chardin, which he says "opened up his impasses to the sun of liberation."[23]

COSMOGENESIS AND CONVERGENCE

That Teilhard de Chardin was a researcher and philosopher who found his points of departure in the findings of

contemporary science could only reassure Senghor, comforting him in the idea that true philosophy of science was neither scientism nor positivism. The cosmology he discovered in Teilhard de Chardin, which put things back together and in their right place for him, appeared to him to be founded on both the "great scientific discoveries of the twentieth century" and an ontology "which did not contradict Negro African ontology" (as he put it in a timidly euphemistic attempt to say that the two ontologies are in accord).[24] As he was in the process of constructing his idea of socialism, Senghor the Catholic was happy to find in Teilhard de Chardin the assertion that the "stuff" of the universe is spiritual and that, even if we should not brush matter aside, it is important to know that the way of matter leads nowhere when the concern is figuring out the world.[25]

Indeed, this task presupposes the ability to think of the world in its totality as both Nature and Man (to use Teilhardian categories) and to restore the latter's place in the heart of the former: one must grasp the world as a *Cosmos* and thus as simultaneously containing physico-chemical determinisms, vital spontaneities and free and conscious choices. We will never be able to start from the rigid laws regulating pure materiality and end up with living spontaneity. On the other hand, if the Cosmos is from the beginning life and freedom, it is possible to see how "by virtue of the effect of large numbers and habitual

behavior," this spontaneity can fall back into Matter with its fixities in which Nature repeats itself through regularities or, as Blaise Pascal says, "imitates itself."[26] The only way to understanding, then, is that there is first the conscious and the free as primitive and unanalyzable facts from which the inert and the determined are subsequently deduced. Teilhard de Chardin often returned to the image of the cone, in which his thought can be summed up: if we follow its generative forces upwards, we find ourselves in a movement of convergence towards the unity of a center, while the reverse movement leads to dissociation without limit. On one side, then, there is Life, Unity, Spirit. On the other, there is Entropy, Plurality, Matter. We find here the distinction made by Bergson—whose *Creative Evolution* Teilhard de Chardin read in 1908 and whom he called "the great Bergson"— between the indivisible *tension* of vital force (*l'élan vital*), which is freedom, forward movement, action and creative force and *extension*, which is synonymous with mechanical necessity, inversion and matter.

With Teilhard de Chardin, rather than a cosmology, we must speak of a cosmogenesis. The Cosmos is first of all alive and life is not an accident that comes about on our earth and from then on finds itself confined there. In addition, the Cosmos is always going towards more life, towards "more-being" in a movement of ever greater

unification that Teilhard de Chardin describes as a "slow but progressive attaining of a diffused consciousness."[27] When we move beyond the biosphere to the noosphere, something new is produced: the vital movement in the human becomes conscious of itself and thus brings about the moral question, otherwise known as the problem of action, of what must be done. We can, Teilhard de Chardin tells us, follow the path of egoism which consists of thinking that movement has attained its end with us (whether one is an individual or a nation). This egoism, parent of all "ethnocentrisms," carries within itself domination and colonization.

We can, on the other hand, fully grasp the meaning of "being born and developing *as a function of a cosmic stream*" and thus see the responsibility of having to continue the effort to bring about more life, more Being, by extending towards ever-greater unity the "generative forces of the world."[28] We understand then that "the value of the World" must continue "to be built up *by a communal effort going forward*" and that the duty of humanization imposes itself once hominization has taken place.[29] Teilhard de Chardin expresses this duty as follows:

> The general convergence which constitutes universal evolution, is not completed by hominization. There are not only minds (*esprits*) on the Earth. *The world*

continues and there will be a Spirit (Esprit) *of the Earth*...[W]e twentieth-century humans...what is the purpose of our absurd objections, our childish interests?...Why do we hesitate to open our hearts wide to the call of the World within us, to the *Sense of the Earth*?[30]

Those who the author of *The Phenomenon of Man* calls "workers of the earth"—i.e., those who are engaged in the creation of a true globalization—thus know that this will not be accomplished except through the convergence of all cultures towards a civilization of the universal and not through the imperialist expansion of a civilization that proclaims itself (in a monologue Teilhard de Chardin points to using the concept of Isolation) the incarnation of the universal. All are equally necessary to the humanization of the earth and all are equally called by the "pole" towards the Omega Point; for any to be denied is for the force of convergence to be blocked. We therefore see that, before being a wish or a politics, the dialogue of cultures—the convergence of "fully conscious nations...for a total earth"—is, first of all, for Teilhard de Chardin and Senghor (whom the former inspires), a cosmic dimension of the duty of Life to go towards more Life.[31] The cosmic reality of convergence explains why Senghor says of Negritude that it is a humanism of the

twentieth century: the affirmation of Africanity cannot actually be left out of the cosmic stream of humanization to which it is ontologically necessary. In his "Hommage à Pierre Teilhard de Chardin" (1963), Senghor concludes:

> Marx and Engels passably ignore us. Teilhard invites us, we Negro Africans, along with the other peoples and races of the Third World, to bring our contribution to the "meeting of give and take." He restores to us our being and summons us to Dialogue—to *more-being.*[32]

CONVERGENCE AND RELIGIONS

We can agree today, in view of the distressing scenes (in Nigeria, for example) where Muslims and Christians clash and kill each other *ad majorem Dei gloriam* (for the greater glory of God), that it would be good to educate people in the fraternal dialogue of religions. It is another merit of Senghor's philosophy of dialogue and a testament to his capacity for prospective vision that he emphasized this aspect of the dialogue of civilizations in an era that was characterized more by the nationalist project and the voluntarism of modernization among the newly independent African states. In 1960, the year which saw the majority of African countries make the transition to sovereignty,

he published an essay in a number of periodicals calling for "Islamo-Christian cooperation," an essay which seems addressed, when we read it today, to our present age of religious fervor.[33]

Senghor was already concerned at that point to see Christianity and Islam, the two religions that share the hearts of Africans ("since," he writes, "Negro African animism is on its way to disappearing"), play their role in the nation-building enterprise and move together, with respect for each other, towards their modernity and "pan-human convergence."[34] In his spiritual socialist terminology, Senghor expresses the point thus:

The goal of Islam and Christianity...is to bring about the will of God. To bring about this will and gain heaven, it is necessary to bring about, down here, fraternity among men by means of justice for all men. For what is justice if it is not the initial equality of given opportunities for all men regardless of race and condition; if it is not, with work, the equitable distribution of national revenue among citizens and global revenue among the nations; if it is not, finally, the equitable distribution of knowledge among all men and all nations?[35]

Aiming at justice, through work, in fraternity and with a concern for equity: this is the principle of movement—i.e.,

the permanent tension towards the future rather than the servile imitation of "tradition"—which is inscribed in the heart of the Christian and Muslim religions. Senghor reads this principle of movement in the words of, on one hand, the Gospel—"Seek ye first the kingdom of God, and his righteousness; and all these things will be added unto you"—and, on the other, the Quran—"Allah does not change a people's lot unless they change what is in their hearts."[36] Senghor's view, which is also faithful to Teilhard de Chardin, is that it is in rediscovering their own principle of movement, their true cosmology of emergence and of the continuing thrust of Life, that religions will converge. Fanaticisms are always religions of death: before anything else, they are religions from which life has left. It is not surprising, then, to see Senghor elsewhere, after having evoked Teilhard de Chardin's philosophy, being attentive to certain Muslim thinkers whose goal, according to him, is analogous to that of Teilhard: "to open Islam to the contemporary world without making it lose its spiritual flame."[37] Among the thinkers he mentions are Shaykh Muhammad Abduh, Jamal ad-Din al-Afghani and Muhammad Iqbal.

It is particularly significant to see Senghor invoke the name of Iqbal in this way, thereby making him the analogue for the Muslim world of what Teilhard de Chardin represented for the Christian world. The major prose work of Iqbal, *The Reconstruction of Religious Thought in Islam*,

had been translated from English into French in 1955, four years before the speech in which Senghor mentions him. The deep connection between these two poets— both from European colonies, both statesmen, both phi- losophers, one Catholic and the other Muslim—did not escape Edgar Faure when, on 29 March 1984, he gave the main address at the election of Senghor to the French Academy: "You composed, under the title of "A l'appel de la race de Saba" (At the Call of the Race of Saba), an anti- capitalist homily, a diatribe against the boards of directors and the bankers, in which we find points of comparison with the conversation between Lenin and the Angels in the Urdu poems of Muhammad Iqbal."[38] We must above all look at the final flight with which Faure concluded his speech, using the lines of Iqbal—whom he deemed "the Islamic apostle of the Universal"—and making Senghor their addressee:

As in the amoebean song that is composed, along- side your work, by the message of the Asiatic poet, founder of a state like you, Islamic apostle of the Universal:

Appear, O rider of Destiny!
Appear, O light of the dark realm of Change! . . .
Silence the noise of the nations,

Imparadise our ears with thy music!
Arise and tune the harp of brotherhood . . .
Has this apostrophe not found its addressee?
I will say your name, Senghor.[39]

To understand the connection between Iqbal and Senghor, the two of whose poetic works do indeed seem at times to respond to each other as in an amoebean song, is to relate it to an evolutionary cosmology at the foundation of their visions of the world which places them in a community of thought with Teilhard de Chardin and, before him, Bergson. Iqbal wrote of Bergson that he was the only philosopher to have truly thought about time. This is why Iqbal, who often meditated on the prophetic word "do not vilify time for time is God," found in the thought of the author of *Creative Evolution* the means to elaborate a philosophical recovery of the cosmology of the Quran as a cosmology of emergence.[40] Like Teilhard de Chardin and Senghor, Iqbal believes in a living God literally, that is to say, emergently. The Senegalese poet-philosopher writes:

God does not descend from the sky, *ex machina* . . . This is no longer the mechanistic and bourgeois God of times past. It is a new God for new times, during which a new law, a new morality and a new

art are being elaborated. It is a God, let us dare
to say, that is less of a creator and more of a per-
sonalizer. He is the Center of centers who attracts
all human centers toward himself in order to make
them flourish by organizing them, who causes
them to eternally *be more* by saving them from their
accidents.[41]

The Indian philosopher-poet says the same thing: at the
Center of creation is the ultimate Ego whose movement is
life and towards whom human egos climb in a movement
that gives them unity and the consistency of a personality,
thereby saving them from the death that is dispersion. The
accomplished human is the one who has realized that to
be is to be in the process of going towards *more Being*, for
"in movement, ceaselessly, is the ocean of life / From each
thing is born vital force."[42]

 This God, who is the alpha and omega of the move-
ment of becoming-personality (and Senghor often insists
that Negritude is nothing other than what the anglo-
phone African world chose to call *African personality*), is
the God who makes possible the dialogue of interlocutors
by orienting it and causing their convergence towards the
Civilization of the Universal. For Levinas is right to say
that a "saraband of countless equivalent cultures," each
justifying itself only within its own context, does not

create a dialogue.[43] Certainly such cultures would form, he says, a decolonized and de-Westernized world, but it would also be a "disoriented" one.[44] A dialogue of cultures is not possible unless it is oriented by the force of life (it is incarnated, for example, by the philosophy of human rights), which teaches cultures that, in order to encounter each other, it is necessary to know how to become decentered and thus surpass egoisms and monologues: this is what Teilhard de Chardin and Iqbal, and Senghor with them, say in unison (often in terms or with images that are quite similar).

In the preface to his French translation of Iqbal's *Bal-i-Jibril* (*L'aile de Gabriel*, 1977; Gabriel's Wing), Mirza Saïd uz-Zafar Chagtaï writes:

In our day, the notion of convergence has become widespread. We are seeing the progress of the idea that large groups can build themselves while safeguarding the specificity of the smaller entities to be grouped together. More and more emphasis is being put on the necessity of safeguarding their values. On the cultural level, for example, do not the voices of "Negritude" conceive of it as a contribution to a humanism of planetary dimensions? On the political level, is not Europe trying to unify without sacrificing the identity of its regions? Are not the UN and

the OAU also attempts at convergence towards the
unity of humankind foreseen by Iqbal?[45]

The deep convergence between the projects of these two
poets from the colonized world, nourished by the same
cosmology of emergence and oriented encounter, cannot
be better shown than this.

THE AFRICAN PATH TO SOCIALISM

Senghor claims his encounter with Teilhard de Chardin
not only brought him back to faith but also confirmed
for him the legitimacy of Negritude as a search for an
"African path to socialism." The author of "What the
Black Man Contributes" understood the Teilhardian no-
tion of the humanization/socialization of the earth as
the promise of a planetary spirit of reconciling differences
after the proverbial beast has been slain. For him, this
beast has a name: *alienation.* Senghor thinks about alien-
ation (in other words, the separation between humanity
and itself) in the context of the cosmology of emergence
that he adopts from Bergson and Teilhard de Chardin,
a cosmology which, he claims, also corresponds to the
African vision of the world. Overcoming alienation and
bringing about the "integral humanism" spoken of by
Jacques Maritain is thus, for Senghor, the task of the
twentieth century.

At the very beginning of his Report to the Constitutive Congress of the Party of the African Federation, given in Dakar on 1 July 1959, Senghor begins by declaring that if the most significant event of the nineteenth century was the Congress of the Communist League held in London in November 1847 (which resulted in the publication of the *Manifesto*), then the Bandung Conference of 1955 would prove to be that of the twentieth century.[46] The reason for this, he explains, is that, in both cases, we find a response to the alienation of the human: just as the proletariat in the nineteenth century saw itself cut off from its humanity, the colonized proletarian nations of so-called peoples of color find themselves alienated in an even more profound manner. In addition to being economically alienated, they are politically, socially and culturally alienated. In the spirit of Senghor, we must emphasize: *above all, culturally*. Alienation is the negation of the cosmic movement through which humanity has flowered. Human becoming is effectively movement towards the realization of higher consciousness and the highest freedom, culminating in the appearance, beyond the *homo faber* and the *homo sapiens*, of what we can call the *homo artifex*, the artist who invented the mode of work that gives him "more being" and makes him "more man." Ultimately, outside of creation, all work is forced.

Senghor reads Marx intensely after the war, and in a specific spirit, for he reads Teilhard de Chardin at the

same time. From "Marxisme et humanisme" (Marxism and Humanism), published in 1948 in the *Revue socialiste*, to "La voie africaine du socialisme, nouvel essai de définition" presented in a Youth Seminar of the Party of the African Federation in May 1960, with "Naissance du Bloc Démocratique Sénégalais" (Birth of the Senegalese Democratic Bloc [BDS], his 1949 Report on Method at the first Congress of the party he and others created after leaving Guy Mollet's socialist party, the SFIO), "Le népotisme contre la révolution sociale" (Nepotism versus Social Revolution, another BDS Report on Method given in 1950), "Socialisme et culture" (his Report at the eighth Congress of the BDS in May 1956) and "Nation et socialisme" (the aforementioned 1959 Report) in between, he affirms the same theses:

1. We must save Marx the humanist, metaphysician, dialectician and artist from a narrowly materialist, economistic, positivist, realist Marxism;
2. There is an African path to socialism which is inspired by black spiritualities, which continues the tradition of communalism on the continent, and which represents the future of the countries creating it—"themselves new, they are creating a new civilization in accord with Africa and with the world of the twentieth century."[47]

These theses constitute the content he gives to the program of rethinking Marx in light of the situation and circumstances proper to Africa; on the practical, political level, they manifested themselves in 1948 in his break with the French socialist party, the SFIO and the creation of the BDS.

Senghor notes that which will later be the point of departure for Louis Althusser's reading of Marx: between the young Marx and the Marx of *Capital*, there is a break. While Althusser will study and celebrate this break as the advent of Marxist science as an "anti-humanist theory" and the invention through this of the "continent of history," Senghor sees self-betrayal by Marx when the latter repudiates his identity as a philosopher and gives to his views the appearance of dogmatic economic petrifactions. And despite all this, Senghor finds, there is unsurpassable humanist philosophy underneath appearances.[48] Behind the technical considerations of surplus value, the spirit of his opposition to alienation and reification in the name of a morality that must accompany the movement towards a liberated humanity composed of creators continues to speak. Thus, when one wonders whether Marxism has been surpassed, Senghor claims, the answer to the contrary affirms that its youthfulness and continued relevance is to be sought and found in the writings of Marx's youth, which had just recently been published at the time when

"Marxisme et humanisme" appears. In that essay, Senghor writes:

> For us, men of 1947, men living after two world wars, we who have just escaped the bloodthirsty contempt of dictators and who are threatened by other dictatorships, what profit is to be had in these works of youth! They so nicely encapsulate the ethical principles of Marx, who proposes as the object of our practical activity the total liberation of man.[49]

This, for Senghor, is the true Marx; the Marx whose cosmology is centered on the artist, in whom alone the human truly coincides with itself; a Marx perfectly captured in these lines from the posthumously published manuscripts that the poet loves to cite:

> An animal's product belongs immediately to its physical body, whilst man *freely* confronts his product. An animal forms things in accordance with the standard and the need of the species to which it belongs, whilst man knows how to produce in accordance with the standard of every species, and knows how to apply everywhere the inherent standard to the object. *Man therefore also forms things in accordance with the laws of beauty.*[50]

Senghor asks: Why insist on the atheism of Marx, phi-
losopher of alienation and freedom? Should we do this
because he saw in religion the most radical separation
from oneself and the essence of reification? He certainly
expressed himself in this way, but we should be careful
not to forget that, upon reflection, what is going on here
is a *"reaction of Christian origin against the historical de-
viations of Christianity"* which "impaired the essence of
religion all the less because the idea of *alienation* is of re-
ligious origin."[51] Senghor clearly has a Teilhardian reading
of the thoughts of Marx on religion and he takes up the
defense of Marx against Maritain: Marx actually aims to
"render man more truly human," to use Maritain's expres-
sion, and all he did was simply draw out the consequences
of the fact that a theocentric humanism is an oxymoron
and an anthropocentric humanism is a pleonasm. To over-
come alienation, in the face of all theocentric "deviations"
that deny freedom, is for the human to coincide with itself
in a movement in which God appears.

Senghor sees in an open and spiritualist socialism the
realization of the humanist demand defined by Maritain:
"that man develop the virtualities contained within
him, his creative forces and the life of reason, and work
to make the forces of the physical world instruments of
his freedom."[52] It is the formerly colonized Senghor that
speaks here, but it is also the Christian who wants to see

the Church in Africa understand its mission as one of liberation from alienation. In a 20 March 1947, letter to the Superior General of the Spiritans, Msgr. Le Hunsec, Senghor (then a Member of Parliament in the French National Assembly) writes:

> If it is desired that Catholicism in Africa shall prog-ress, it is essential, in my view, that missionaries not only approve but also advocate a radical change in the relationship between Europeans and indigenous people, above all in political institutions. They must keep themselves, before anything else, from engag-ing in antisocialist activity or even anticommunism. I permit myself to speak of this with so much liberty since I am neither a freemason nor a communist and, on occasion, I proclaim myself a Catholic in public meetings.[53]

SOCIALISM AND AFRICAN ART

Senghor is thus persuaded that socialism "in general" does not exist unless it is incarnated, inculturated. There can be no socialism in Africa unless it is African. He is equally persuaded that socialism, in addition, has to learn from Africa in order to be able to truly be itself. It must learn, to begin with, not to go astray in the search for a socialist

art which ends up symbolizing the absence of freedom. It is quite significant and in conformity with the core of his philosophy that when he declares his opposition to the Soviet system and its translation of Marxism into "real socialism," he does it in the name of the lesson taught by African art. He contrasts the socialist realism by means of which, he says, young African intellectuals believe it necessary to betray themselves, with African *sub-realism*, inviting them to find their own truth in the freedom of making dreams and life meet. To be able to find beneath reality the force that it manifests and directly present it through work that gives access to the universe of pluralist energetism is to be a sub-realist and to understand the metaphysical and aesthetic lesson of African art, the purpose of which is to satisfy "our cosmic sense, by means of which we live happily."[54] And this is the same thing, for Senghor, as the approach of that Negro, Rimbaud, who assigns art the goal of "changing life."

Does socialism also aim at truth in art? It does, indeed. But, Senghor asks, what is it to be truthful? Here too we must know how to return to the true Marx, going past Marx himself if necessary, in order to destroy the false equation: truthful equals to realist. What we need to understand is that the point is not to photograph reality in various ways but to transform it, i.e., to recreate it. This transformative force, this freedom "that leads men, even

when they are Soviets, above all if they are artists," is the power of *fabulation*.[55] This is what Vladimir Mayakovsky, Senghor claims, revealed to the highest degree; it is also naturally—that is to say, originally—inscribed in the African aesthetic.

It is in the name of this sense of fabulation that Senghor deplores the fact that young African authors, since they take themselves to be "revolutionaries," flatten their work, reducing it to the value of testimony and direct protest against colonialism. Senghor has often been reproached for having not spoken against the domination of colonialism with sufficient anger and violence. He is reproached for having, for imperial France, the tender feelings of one who always separated what he called an "eternal France" attached to freedom for all from a "circumstantial France" presenting the face of colonial domination. He is reproached for having gone as far as asking God, in a "Prayer for Peace" (his famous poem of pardon), to place France at His right hand. Nevertheless, even if he wrote no impassioned, incandescent *Discourse on Colonialism* as Césaire did, Senghor is in total and constant rebellion against the very idea of colonialism. In his obstinate refusal of its very premises, he often smiles like the Serer he is, but it is this obstinacy that puts him in opposition to Father Lalouse at such a young age and it is this that speaks in him with a calm that is more devastating

than a cry of revolt when he gives his talk in 1937 at the Chamber of Commerce in Dakar.

Thus when Senghor speaks to African intellectuals about what it means to do politics in art, he does so to remind them that they must not forget themselves, both literally and figuratively. What they must not forget (since, in doing so, they forsake their own intentions) is that testimony and protest in art are not about affecting the eloquence of hate but rather practicing "black humor," i.e. affirming the strength to live even in the face of inhumanity. In this way, proceeding to the negation of the colonial negation is, simply, self-affirmation and self-expression with the art of fabulation, which is exemplified so well in the romanesque writing of Birago Diop or Camara Laye and which consists in the talent to create what Picasso called "powerful reality."

CONCLUSION
MIXTURE

Everyone must be mixed in their own way.

Léopold Sédar Senghor[1]

OVER THE COURSE of 50 years, from "What the Black Man Contributes" to *Ce que je crois*, Senghor constructed a philosophy of African cultures not by enclosing himself within them but by being in dialogue with the thoughts that dominated his century. He read Bergson, Frobenius, Teilhard de Chardin, Tempels, Griaule, Marx, Sartrean existentialism, Bachelardian epistemology and much else, all through the lens of his own constant concern for the affirmation of an Africanity which is itself contained, for him, in the answer to the question of what the art of the black continent means. What Senghor found in all these readings is, in short, that this art finds its true meaning as a testament to an ontology

of vital forces in an emergent cosmology open to human action for the purpose of overcoming forms of alienations and gaining access to the freedom of the *homo artifex*.

This question of art was not of purely academic interest but was embedded in the context of the colonial negation, in which access to freedom had the very concrete sense of the affirmation of the equal dignity of all cultures, thus removing all legitimacy from imperial domination. The Senghorian philosophy of "all is culture," this conviction that what is at stake is the demonstration and defense of cultural identities, has often been reproached, sometimes unjustly. Thus, when Nigerian writer Wole Soyinka mocked Negritude's affirmation of the self by saying that a tiger does not strut about proclaiming its "tigritude" but, rather, manifests it by pouncing on its prey, he quite obviously had laughter on his side. As for philosophical good sense, it was to be found in Senghor's response: the tiger is a beast. What constitutes the human—what makes him the co-creator of the world that it is his mission to carry to completion—is that his Being is not a state but a question and a worry. The human being is always in torment concerning his becoming *more-being*.[2]

The affirmation of the self was a natural reaction to colonial domination. Today, in the era of so-called postcoloniality, the time has come for nomadic identities, hybridity and creoleness. What does this mean? Following

the article on it in the *New York Times*, Nicole Bacharan talks in her book *Faut-il avoir peur de l'Amérique?* (Should We Be Afraid of America?) about a DNA test performed at an American university in Spring 2005 on students in a class on race relations.[3] The goal was to determine the "ethnic" origin of their ancestors. Bacharan indicates the interest taken by the class in the test. Thus a student who thought himself simply black, after discovering that he was of 48 percent European origin, insisted on saying he was "culturally" black. Many of them were delighted to discover, though, at varying percentages, "others" than the ethnic identity they were raised in. Concerning the fact that mixture was clearly the predominant identity of those who took the test, Bacharan concludes that the "multiple memberships," the scrambled "racial maps" and identities characterizing our time, constitute "a source of relief": "The less that identity is closed," she writes, "the less 'the Other' appears foreign and threatening. It is truly a new world that is being invented."[4]

It is certainly welcome, this post-essentialist "new world" lacking an obsession with alterity. It must be celebrated from the perspective that it opens up a humanism of hybridity against, for example, the *neo-Negritudes* that today believe it necessary to construct themselves as an Afrocentrism that combines victimization and hate. Must we then see Senghorian thought as a historical moment,

perhaps necessary but surpassed today, a simple reminder of the old world on the ruins of which the new humanism is in the process of being constructed? If we hold to a simplistic chronology according to which there is an essentialist (colonial) stage of history which is succeeded by our (postcolonial) era that has very happily become "creolist," then no doubt yes. But it is precisely not that simple, which is to say that there has never existed, with Senghor in particular, a pure essentialism, all of a piece, to be taken or to be left. Negritude is not the ideology of separated identities that, despite his protestations, many critics of Senghor have taken it to be.[5] Hybridity is always at work deconstructing his essentialist assertions and the Senghorian obsession with mixture is a Penelope ceaselessly making sure to undo fixed differences: "the humanism of hybridity" could very well have been one of the poet's slogans.

One of the philosophers Senghor likes to bring up is the "father of prospective": Gaston Berger. Indeed, as a socialist, Senghor often insisted on the importance of planning grounded in a prospective vision. Berger is also his reference point when it comes to thinking about the interdependent world in which we live (and whose transformations are becoming ever more accelerated) in order to better see the future for the purpose of mastering it. In Bergerian prospective ("a method of thought and action,"

Senghor writes, "for constructing [the] future with a human end"), he sees "a humanism of the twenty-first century."[6] His interest in Berger, in whom he finds the influence of Bergson and Teilhard, equally concerns the other aspect of his thought: characterology, of which he is considered the founder in France.

Both prospective and characterology occupy an important place in Senghor's reflections, but also the very person of Berger, in whom he sees the perfect realization of the *métis* (mixed person). He could not help but be attracted by the personality of Berger, who was Senegalese by his paternal grandmother. It is, in fact, by joining the school of characterology that Senghor wants to explain "the wealth of *aptitudes*, of gifts, that, as a result of *situations* and *influences*" made Berger "*the philosopher of Action*" that he was.[7] Since prospective itself is symbiosis between the "hard" science that performs analyses and extrapolations and the intuitive science that imagines and dreams the future, Senghor sees in Berger's thought the happy hybridity that responds "to the dual call of discursive reason and intuitive reason."[8]

Cameroonian philosopher Marcien Towa expressed extreme irritation at the sight of Senghor tracing this hybridity to a biological infrastructure and making it a mix of different hybridities: the "Albo-European" and "Negro-African" sides of the philosopher of prospective,

in Senghor's terminology.⁹ However, if Senghor made an example of Berger, it is in fact because biology is neither the determining nor the most important factor. Let us compare Senghor's explanation of Berger's personality by the heredities that come together in him with what he said about *himself* on the same level. At the end of a 1950 article written for a special issue of *Présence Africaine* entitled "L'Afrique s'interroge: subir ou choisir?," Senghor concludes his reflections with a "personal experience":

> I think of those years of youth, at that age of division at which I was not yet born, torn as I was between my Christian conscience and my Serer blood. But was I Serer, I who had a Malinké name—while that of my mother was Peul? Now I am no longer ashamed of my diversity, I find my joy, my assurance in embracing with a *catholic* eye all these complementary worlds.¹⁰

This is a strange experience, certainly more symbolic than truly "personal." Here, to be born is to pass the "age of division," i.e. to integrate the completely disparate: a "conscience" with a "blood" that is disturbing it, a membership with a name that contradicts it. What this "experience" tells us is that there is no origin, that regression never reaches its end and it remains unassignable—does

Senghor not gladly speculate as well on the Portuguese origin of his family name, which might come from *"senhor"*?

In other words, in searching for origin, one is always brought back to the exploration of one's own hybridity, to the discovery that one is "legion." Decomposition will not end until one understands that what counts is being born to one's integrated whole, to the "catholic" aptitude of holding together with "assurance" all the elements that one is. What makes Berger an example? Ultimately, that he is no more mixed than Senghor or anyone else. We find Senghor evoking the "mixed being" of many others: Miguel Angel Asturias (who, Senghor writes, cultivated "the mix in himself in order to make it an alliance"), Marc Chagall and more.[11]

We thus comprehend that mixture for Senghor is a rallying cry: "Everyone must be mixed in their own way." It is true that he dedicates many pages to biology and characterology[12] but it is always, ultimately, in order to insist on the idea that mixture is a cultural affair. Mixture is not the effect of a simple encounter, a state, but a *duty-to-be* that cannot be reduced to biological infrastructure: it is something that is *cultivated*.

It is with civilizations as it is with individuals: mixture is their virtue. For Senghor, mixture is both the foundation and final end of civilization. It is the foundation because all human civilization is only such because of

mixture. This is true whether the civilization in question is Egyptian, Greek, Mediterranean, today's African, American, etc.[13] To put it simply, there is never a zero degree of mixture, a moment in which one grasps essential identities in their separateness and "purity" in advance of encounter and mixing. Multiple heritages that do not cease to multiply: this is humanity itself. Yet *all* heritages are to be claimed. This is the price of integral humanism Maritain speaks of and this is why Senghor insisted on calling the philosophy of Negritude a "humanism of that twentieth century" that passed away with himself, so that no heritage would be ignored. Thus mixture which is foundation becomes horizon as well as the final end: the civilization of the universal.

A theory of fluid cultural combinations is very present in Senghor's work; it surfaces here and there from beneath a generally essentialist discourse, resulting in a more nuanced racialism or perhaps even de-racializing his thought. It is necessary, indeed, to take full account of the fact that he is a philosopher of mixture at least as much as of Negritude. And when he pays tribute to the mixed, he does not make the mixed a derived being but the primary, primordial assertion of the freedom to create that is culture itself. For Senghor, all living culture is mixed and the mixed one is the creator of culture for he is the freedom to "fashion, from reconciled elements, a

strong and exquisite work."[14] The poet Nimrod very appropriately contrasts the "affirmative word" of mixture that Senghor praises in 1950 with the succession of refusals and negations with which the "praise of creoleness" begins.[15] We can thus see in Senghor a becoming-Negro showing through beneath what is called "Negritude" to the point of sometimes superimposing itself upon it. At such moments Senghor begins to speak of fluidity and movement rather than essence and permanence. We can therefore evoke without problem or paradox, let us remember, a becoming-Negro of Rimbaud, Picasso or Claudel, or even of French, German or Dutch culture, of this or that period, in this or that area, etc.

We can also speak of the past and evoke the existence of a black Greece without any racialist obsession, drawing on the remark Guillaume and Munro make in a footnote of their book on African sculpture. After having asserted that Greek statuary, unlike African sculpture, appeals to the category of "what would be humanly desirable in flesh and blood," they write that this "does not apply to all Greek sculpture, some of which, especially the archaic, involves considerable distortion for the sake of design."[16] Senghor, in a number of passages, insists on the existence of Negritude in ancient Greece.[17] To speak of a becoming-Negro in a mixed civilization like ancient Greece has the merit of saying that the same world experienced tension

between a creative principle ordered by the ideal of the beautiful form and another drawing on the deep sources of emotion. And we can, with Nietzsche, call the former "Apollonian" and the latter "Dionysian." Such a reference will later be made by Senghor himself—for example, in a talk given at the University of Tübingen in May 1983, in which he puts Nietzsche beside Bergson as an actor in what he calls "the Revolution of 1889":

> For [Nietzsche], man's vocation and fulfillment is less in truth than in life: the free will of man, which makes him *overman*, as he invents new values which are drawn, certainly, from the will but, more profoundly, from intuitions and sensibility. It is him also who preaches "the eternal return" to the symbiosis of the Apollonian spirit and the Dionysian soul, with the emphasis placed on the latter. The Revolution of 1889 was ripe. Let us not forget that it is in 1883–1885 that *Thus Spoke Zarathustra* appears.[18]

We must end on two important points. One, that the African art of yesterday, as Apostel asserts, does indeed supply a convincing "proof" for African philosophy as pluralistic energetism and thus also for Senghor's thought: the ontology of vital forces provides a reasonably good account of this art, both in terms of its different styles and

the unity that characterizes it. That said, and this is the second point to emphasize, if the African artist of yesterday had access to this ontology as the driving force behind his creativity, this does not mean that there is a specific exclusive difference characterizing Africans in general, who are welded together by a collective unconscious metaphysics. Consequently, the African artist today does not need to find the same access to a metaphysics that has essentially disappeared in order to be himself and to be faithful to his history. Senghor celebrated an African creativity that in many ways contributed to giving twentieth-century art its appearance and colors, particularly by convening the World Festival of Negro Arts in Dakar in 1966 (a high point of his presidency); he also wished for the existence of a Dakar school of art that would defend and demonstrate for today the aesthetic of rhythm and asymmetric parallelisms. This second battle was lost in advance for it was not necessary, as shown by contemporary African artists (the Senegalese in particular): Africanity is, for them, an open question to be ceaselessly explored.

We will note finally that the centenary of Senghor's birth (2006) is also the year in which the so-called Musée des Arts Premiers, which we now simply call the Musée du Quai Branly, had its inaugural opening in Paris. Has Apollinaire thus attained his goal, he who consistently demanded that the arts of the non-European world be

considered as such and displayed in a place where it would be clear that they are for aesthetic appreciation and not ethnological curiosity? The future of this new museum will tell. We can nevertheless advance the view that the lively dialogue it has already organized (both between its collections drawn from different spaces and times and between the objects on display and the cosmopolitan crowds drawn by curiosity since its opening) seems to suggest it will be what Apollinaire and Senghor wanted the philosophy of African art to be: a tribute to mixture.

ACKNOWLEDGMENTS

THE TASK OF reading "Senghor as a philosopher" was encouraged by Jean-Joseph Goux of Rice University and Abiola Irele of Harvard University. The Alice Kaplan Institute for the Humanities at Northwestern University offered me the possibility, by making me one of their fellows, to dedicate a part of the 2005–06 academic year to writing the following chapters, which draw often on lectures I had given on Senghor's thought. I thank the then directors of the Institute, Robert Gooding-Williams and Elzbieta Foeller-Pittuch, for their hospitality. I thank Senegalese philosopher Amady Ali Dieng, my colleagues and friends at Northwestern University, Nasrin Qader and Bill Murphy, for their useful remarks. I have benefitted much from my exchanges with Babacar Mbengue, Ramatoulaye Diagne, Philippe Gouet, Hady Bâ and Françoise Blum. Finally, I wish to express gratitude to the Northwestern students who attended my Spring

2006 seminar dedicated to Senghor's philosophy for all that this book owes to our dialogue. Chike Jeffers was one of them. Today he is my colleague and friend who translated this book from French.* *Merci*, Chike.

* The translation differs from the original French only by a few footnotes in which I make references to books on Léopold Sédar Senghor published in the United States.

ENDNOTES

INTRODUCTION TO THE 2023 EDITION

1. Bénédicte Savoy, *Africa's Struggle for Its Art: History of a Postcolonial Defeat* (Princeton, Princeton University Press, 2022).
2. Quoted and translated into English in *Africa's Struggle for Its Art*, pp. 5–6.
3. Its history and attitude concerning restitution has earned it a nickname in Dan Hicks' book: *The Brutish Museums: The Benin Bronzes, Colonial Violence and Cultural Restitution* (Pluto Press, 2020).
4. Aimé Césaire, "Discours sur l'art africain," in *Poésie, Théâtre, Essais et Discours*, Director of publication: Albert James Arnold (Paris: CNRS Editions/Présence africaine Editions, 2013), p. 1568.
5. Walter Benjamin, *The Work of Art in the Age of Its Technological Reproducibility and Other Writings on Media*, edited by Michael W. Jennings, Brigid Doherty, and Thomas Y. Levin, translated by Edmund Jephcott, Rodney Livingstone, Howard Eiland, et al. (Cambridge, MA & London, England: The Belknap Press of Harvard University, 2008).
6. Janet Vaillant, *Vie de Léopold Sédar Senghor: Noir, Français et Africain* (Life of Léopold Sédar Senghor: Black, French and African) (Roger Meunier trans.) (Paris: Karthala, 2006), p. 421.

INTRODUCTION

1. Friedrich Nietzsche, *The Birth of Tragedy and The Case of Wagner* (Walter Kaufmann trans.) (New York: Vintage Books, 1967), p. 31.

2. Available in English as: *Creative Evolution* (Arthur Mitchell trans.) (New York: Henry Holt and Company, 1911).

3. See Henri Bergson, "Philosophical Intuition," in *The Creative Mind: An Introduction to Metaphysics* (Mabelle L. Andison trans.) (New York: Citadel Press, 1992), pp. 107–29. Bergson writes: "[A]s we seek to penetrate more fully the philosopher's thought instead of circling its exterior, his doctrine is transformed for us. In the first place its complication diminishes. Then the various parts fit into one another. Finally the whole is brought together into a single point, which we feel could be ever-more closely approached even though there is no hope of reaching it completely. In this point is something simple, infinitely simple, so extraordinarily simple that the philosopher has never succeeded in saying it. And that is why he went on talking all his life" (pp. 108–9).

4. Jacques Louis Hymans, *Léopold Sédar Senghor: An Intellectual Biography* (Edinburgh: Edinburgh University Press, 1971).

5. Armand Guibert speaks of it, quite justifiably, as "a doctrine scattered in hundreds of manifestos, articles, reports, essays, speeches, addresses, and other circumstantial writings." See Armand Guibert and Seghers Nimrod, *Léopold Sédar Senghor* (Paris: Seghers, 2006), p. 38.

6. Available in English as: *Time and Free Will: An Essay on the Immediate Data of Consciousness* (F. L. Pogson trans.) (London: George Allen & Unwin, 1910).

7. First translated into English in 1896. Available in one of many English translations as: *Thus Spoke Zarathustra* (Adrian del Caro trans., Robert Pippin ed.) (Cambridge: Cambridge University Press, 2006).

8. In 1932, in the March issue of *La Revue du Monde Noir*, an article appeared by a Senegalese student from Saint-Louis, P. Baye-Salzman. In this article, the art critic lists the French artists who have undergone the influence of African art: the painters Pablo Picasso, André Derain, Henri Matisse, André Dunoyer de Segonzac, Maurice de Vlaminck and Amadeo Modigliani; the writers Waldemar George, Paul Guillaume, Thomas Munro, André Breton and André Salmon; the poets Guillaume Apollinaire, Jean Cocteau, Blaise Cendrars and

Paul Eluard. Based on the fact that these artists "did not hesitate to exalt in their works the virtues of black aesthetics" and find there the resources to renew and heighten their inspiration, the author of the article concludes that the "revelation" of African art "came at the right moment [for] it corresponds to the most expressive data, the best fitted to satisfy the contemporary anxiety." See P. Baye-Salzmann, "L'Art Nègre, son inspiration, ses apports à l'Occident" (Negro Art, Its Inspiration and Contribution to [the] Occident') in *La Revue du Monde Noir, 1931–1932: Collection complète, no. 1 à 6* (Paris: Jean-Michel Place, 1992), p. 302 (translation modified).

9. *Nègre je suis, nègre je resterai* (Negro I Am, Negro I Will Stay), he proclaims in the title of his most recent book of interviews with Françoise Vergès, thus demonstrating his suspicion of the praise of creoleness that, under the pretext of multiplying heritages, can have the effect of burying the African one. See Aimé Césaire, *Nègre je suis, nègre je resterai : Entretiens avec Françoise Vergès* (Paris: Albin Michel, 2005).

10. Patrick Chamoiseau and Raphael Confiant, *Lettres créoles, Tracées antillaises et continentales de la littérature: Haïti, Martinique, Guadeloupe, Guyane 1635–1975* (Creole Letters, Caribbean and Continental trajectories of Literature: Haiti, Martinique, Guadeloupe, Guiana 1635–1975) (Paris: Gallimard, 1999), p. 171.

11. See Nietzsche, *The Birth of Tragedy*, p. 19.

12. Published in Léopold Sédar Senghor, *Liberté 1: Négritude et Humanisme* (Paris: Éditions du Seuil, 1964), pp. 22–38. Available in English as: "What the Black Man Contributes" (Mary Beth Mader trans.) in Robert Bernasconi (ed.), *Race and Racism in Continental Philosophy* (Bloomington, IN: Indiana University Press, 2003), pp. 287–301.

13. Léopold Sédar Senghor, *Ce que je crois: négritude, francité, et civilisation de l'universel* (What I Believe: Negritude, Frenchness and Universal Civilization) (Paris: Grasset, 1988).

14. Léopold Sédar Senghor, *Liberté 3: Négritude et Civilisation de l'universel* (Negritude and the Civilization of the Universal) (Paris: Éditions du Seuil, 1977).

15. The expression is by Gayatri Chakravorty Spivak who claims that even if we have to oppose essentialism and universalism because they are in part linked with domination, we cannot dispense with them totally for strategic reasons. Sometimes, in the name of the fight against domination, we must choose in favor of an essentialism that will thus be "strategic." See Gayatri Chakravorty Spivak, *The Postcolonial Critic: Interviews, Strategies, Dialogues* (Sarah Harasym ed.) (New York: Routledge, 1990), pp. 11–12.

EXILE

1. Léopold Sédar Senghor, *La poésie de l'action: conversation avec Mohamed Aziza* (Paris: Stock, 1980), p. 45.
2. Jean-Paul Sartre, *Being and Nothingness: An Essay on Phenomenological Ontology* (Hazel E. Barnes trans.) (New York: Washington Square Press, 1992 [1956]), p. 671 (translation modified).
3. "A Dangerous Mystification: The Theory of Negritude," *La Nouvelle Critique, Revue du Parti Communiste Français* (June 1949): 34–47.
4. Jacques Louis Hymans correctly notes that it is not coincidence that Gabriel d'Arboussier's critique adopts the terms used in Georges Politzer's critique of Henri Bergson published by Les Editions Sociales in 1947: *Le bergsonisme, une mystif ication philosophique* (Bergsonism: A Philosophical Mystification). See Hymans, *Léopold Sédar Senghor*, p. 125.
5. All the volumes of poetry are available in English as part of *The Collected Poetry* (Melvin Dixon trans. and introd.) (Charlottesville, VA: University of Virginia Press, 1991).
6. The article insinuates that Présence Africaine was subsidized by "imperialism."
7. Thus the text denounces the irruption of the ethnic factor in the form of pan-Negroism, panslavism and Zionism (p. 40). We find here the classic argument against the "objective ally" of imperialist forces: if they can use you in one way or another, then you are—*objectively*—on their side.
8. Sartre, *Being and Nothingness*, p. 671.
9. Ibid.

10. Ibid., pp. 671–2.
11. Ibid., p. 672.
12. Jean-Paul Sartre, *Saint Genet, Actor and Martyr* (Bernard Frechtman trans.) (New York: George Braziller, 1963). Lilyan Kesteloot, discussing the way Sartre took hold of the movement expressing itself in the anthology, writes: "After his brilliant analysis—which is in itself one of the most beautiful pieces of literature Sartre has written—everyone began discussing *Négritude*, but using the definitions Sartre proposed for it. There has been more reflection on and discussion of what Sartre wrote about *Négritude* than about what was said about it by the Negroes themselves (Césaire, Senghor, Alioune Diop, etc.), who always spoke about it as above all an experience!" See Lilyan Kesteloot, "L'après guerre, l'anthologie de Senghor et la préface de Sartre" (The post-war years, Senghor's Anthology and Sartre's Preface) in *Ethiopiques, revue négro-africaine de littérature et de philosophie* 61 (1998). Available at http://ethiopiques.refer.sn/spip.php?article1302 (last accessed on 9 September 2011).
13. Edmund White, *Genet: A Biography* (New York: Alfred Knopf, 1993).
14. Ibid., pp. 381, 675.
15. Jean-Paul Sartre, *Black Orpheus* (S. W. Allen trans.) (Paris: Présence Africaine, 1963), p. 25 (translation modified).
16. Ibid.
17. Ibid., p. 26.
18. Ibid., p. 25.
19. Available in English as *Notebook of a Return to the Native Land* (Clayton Eshleman and Annete Smith trans. and eds.; André Breton introd.) (Middleton, CT: Wesleyan University Press, 2001).
20. Ibid., p. 11 (translation modified). Sartre thus contrasts the revolutionary authenticity of those who live in exile from Being and in the poetic gap with a poetry that claims to be that of "the future revolution" but which "has remained in the hands of the young well-intentioned bourgeois who draw their inspiration from their psychological contradictions, in the antinomy of their ideal and their class, in the uncertainty of the old bourgeois language" (p. 14).

21. Frantz Fanon, *Black Skin White Masks* (Constance Farrington trans.) (New York: Grove Press, 1991), pp. 133–5. The translation has been corrected: Fanon does say "unforgiving blow" and not a "blow that will not be forgiven" as the translator has it.

22. Aimé Césaire, "Lettre à Maurice Thorez" in George Ngal, *Lire le Discours sur le colonialisme d'Aimé Césaire* (Paris: Présence Africaine, 1994), p. 136.

23. Ibid., p. 137.

24. Ibid., p. 138.

25. Ibid.

26. Aime Césaire, "Discours sur la Négritude" in *Discours sur le colonialisme* (Paris: Présence Africaine, 2004), p. 82. The lecture was given on 26 February 1987 at Florida International University in Miami.

27. This is contrary to Marcien Towa's claim that "it is, no doubt, partly under the influence of Senghor that Sartre so easily likened *Négritude* to a search for "the black soul" and an "antiracist racism." "Towa contrasts what is, in his view, a Senghorian Negritude marked by religiosity with a more revolutionary Negritude that he sees in Césaire. Thus, if Sartre speaks of the black soul, it is because he is under the "influence" of Senghor. See Marcien Towa, *Poésie de la négritude, approche structuraliste* (Poetry of Negritude: A Structuralist Approach) (Sherbrooke: Naaman, 1983), p. 266.

28. Sartre, *Black Orpheus*, p. 31.

29. Ibid., p. 32 (translation modified).

30. Léopold Sédar Senghor, *Anthologie de la nouvelle poésie nègre et malgache de lange française* (Anthology of New Negro and Malagasy Poetry in French) (Paris: Quadrige/PUF, 1948), p. 135.

31. Ibid.

32. This is how Senghor describes this ontology of vital forces, to which we will return: "The entire universe, visible and invisible—from God to the grain of sand, including spirits, ancestors, animals, plants and minerals—is composed of 'communicating vessels,' interdependent vital forces, that all emanate from God. Living man, because he is a force endowed with *freedom*, is capable of *rein-forcing* his vital force or, through

negligence, '*deforcing*' it, though he can only do this by making other forces act or letting them make him act." See Birago Diop, *Les nouveaux contes d'Amadou Koumba* (Tales of Amadou Koumba) (Paris: Présence Africaine, 1958), pp. 15–16.

33. Ibid., p. 21.

34. We find numerous examples of this "playing" which is not simply translation in the work of Diop, who is a master of a style of writing that has been called "feigned orality." He has been able to employ it with subtlety, unlike other authors who have made it into a mechanical writing technique (speaking a *different* language in French) and who end up being tiresome: when all is gap, there is no more gap.

35. Looking back at the movement's beginnings in a 1976 lecture "La Négritude, comme culture des peuples noirs, ne saurait être dépassée" (Negritude, as the Culture of Black Peoples, Cannot Be Surpassed), Senghor explains: "[D]uring the first years of the movement, in the Latin Quarter, Negritude was, I freely recognize, a sort of moral ghetto, a ghetto tinted with racism in the sense that with the enthusiasm of the return to the source and the discovery of the black Grail (to speak like Sartre), we came to find Albo-European values insipid... Nevertheless, we were not long in coming out of this ghetto. I have spoken elsewhere of my personal experience more than once: how two years of contemplation in the *Frontstalags* as a prisoner of war got me out, cured me of the black ghetto." See Léopold Sédar Senghor, *Liberté 5: Le Dialogue des Cultures* (Paris: Éditions du Seuil, 1993), p. 107.

36. Senghor, *Anthologie*, p. 135.

RHYTHMS

1. Léopold Sédar Senghor, "Élégie pour Martin Luther King" (Elegy for Martin Luther King) in *Poésie complète* (Paris: CNRS Editions, 2007), p. 587 (translation modified).

2. Originally published in *La Revue immoraliste* (April 1905). available in English as: "Picasso as Painter and Draftsman" in *Apollinaire on Art : Essays and Reviews 1902–1918* (Leroy C. Breunig ed., Susan Suleiman trans.) (New York: Viking Press, 1972), p. 13.

3. Marie-Laure Bernadac and Paule du Bouchet, *Picasso: Master of the New Idea* (London: Harry N. Abrams, 1993), p. 41.

4. Ibid., p. 42.

5. André Malraux "Les Voix du silence" (The Voices of Silence) in *OEuvres complètes*, Vol. 4 (Paris: Gallimard, 2004), pp. 204–5.

6. Guillaume Apollinaire, "Exoticism and Ethnography" in *Apollinaire on Art*, pp. 244, 246.

7. André Malraux, *La Tête d'obsidienne* (Paris: Gallimard, 1974). Available in English as *Picasso's Mask* (June Guicharnaud trans.) (New York: Holt, Rinehart and Wilson, 1976).

8. Douglas Newton, *Masterpieces of Primitive Art* (New York: Alfred Knopf, 1982); for the Malraux foreword, see pp. 11–13.

9. Malraux, *Picasso's Mask*, pp. 10–11 [I have corrected an error and added missing components of the translation.—Tr.]. Senghor recalls his encounters in the 1930s with "the artists of the School of Paris, or, if one prefers, of *Cubism*" when they had their headquarters at the Cafe de Flore. "Sometimes," he writes, "one of them would suggest: 'Why don't we go see Picasso?' he used to live not very far, two or three blocks from there. I still remember Pablo Picasso genially walking me to the door, as I was taking my leave of him, and saying to me as his eyes met mine: 'We must remain savages.' And I would answer: 'We must remain Negroes.' And he would break into laughter" (Senghor, *Ce que je crois*, p. 221).

10. This word, "savage," closer to "untamed" than "primitive," is to be understood as that which grants the artist the right that, according to Malraux, Picasso read in African forms: "the right to the arbitrary and the right to freedom" (Malraux, "Foreword" in Newton, *Masterpieces of Primitive Art*, p. 15).

11. Ibid., p. 16.

12. Ibid.

13. Quoted from Douglas Fraser's "Introduction" to an exhibition of photos of African art organized by the Department of Art History and Archaeology, University of Columbia. See Douglas Fraser, *African Art as Philosophy* (New York: Interbook, 1974), p. 1.

14. Leo Apostel, whose *African Philosophy: Myth or Reality?* (Ghent: E. Story-Scientia, 1981) uses a precise, analytical approach to

prove that, ultimately, Placide Tempels and those who thought in the tradition of his *Bantu Philosophy* were right to see "pluralist energetism" as the characteristic feature of African ontology. Apostel quotes W. E. Abraham speaking of the Akan people: "As the Akans could not write, they expressed their philosophico-religious ideas through art, through the *timeless, immemorial, silent and elemental power* so characteristic of African traditional art" (W. E. Abraham, *The Mind of Africa* [London: Weidenfeld and Nicolson, 1962], p. 111).

15. Léopold Sédar Senghor, "What the Black Man Contributes" in Bernasconi (ed.), *Race and Racism in Continental Philosophy*, p. 289.

16. Ibid., p. 296.

17. Paul Guillaume and Thomas Munro, *Primitive Negro Sculpture* (New York: Harcourt, Brace and Company, 1926). The French version was published three years later: *La sculpture nègre primitive* (Paris: Editions G. Crès and Cie, 1929).

18. The original English edition contained a supplementary final chapter on the relation between primitive Negro sculpture and contemporary art. In this conclusion, after having quoted from numerous modern artists whose works owed something to Negro art, the authors write: "These [moderns] exemplify the power which the anonymous artists of the jungle are exerting upon the mind of a race widely separated from them in blood, civilization, geography and time. The modern works are not, of course, a basis for judging the merit of the ancient sources themselves. Primitive [Negro] art, like most great originations, is essentially inimitable, and some of its power is apt to be lost in modern versions" (Guillaume and Munro, *Primitive Negro Sculpture*, p. 133). See also Bernasconi (ed.), *Race and Racism in Continental Philosophy*, p. 289.

19. Ibid., p. 10.

20. Ibid.

21. Ibid., p. 13. Along the same lines, in an interview given in 1967 and published in 1994, Michel Leiris declares that a concern to create that which is African, for the artist, results only in "artificial things." He adds: "What is to be done? I cannot continue to make masks or statues that refer to things in which I

no longer believe or which are very distant from me...those African painters who will not give a thought to being African will create works in the presence of which we shall say to ourselves, 'Only an African could have done that.' They will have achieved an artistic Africanism without meaning to do so. To look for it deliberately is like socialist realism..." (Michel Leiris, *"Au-delà d'un regard"*: *Entretien sur l'art africain par Paul Lebeer* ["Beyond a glance": Interview on African art by Paul Lebeer], Lausanne: La Bibliothèque des Arts, 1994, p. 91).

22. Jean-Godefroy Bidima explains this strange reversal accomplished by the logic of trade which sees the foreign consumer defining what African art is and those that make it defining their own identity in conformity with this expectation. "African art?" he writes, "It is the art of Africans which is reviewed, graded, sold and presented by whites" (Jean-Godefroy Bidima, *L'art négro-africain* [Paris: Presses Universitaires de France, 1997], p. 6).

23. Guillaume and Munro, *Primitive Negro Sculpture*, p. 11.

24. Ibid.

25. Ibid., p. 5.

26. Ibid., p. 7.

27. Clive Bell, *Art* (New York: Frederick A. Stokes, 1913), p. 53

28. Ibid., p. 54.

29. Ibid.

30. Guillaume and Munro, *Primitive Negro Sculpture*, p. 30.

31. Ibid.

32. Ibid., p. 33.

33. Ibid.

34. Ibid.

35. Ibid., p. 32.

36. Ibid., p. 35.

37. Ibid., p. 37.

38. Ibid., p. 37–8.

39. Ibid., p. 52.

40. Describing a mask, Guillaume and Munro write: "The eyes are rough, irregular circles, boldly outlined; the huge upper lip, as a semicircle, relates the mouth to them and joins in a rhythmic series that is continued above the eyes. The lower lip, a stiff

contrasting horizontal, relates the mouth to the base of the nose and to the horizontal lines of the forehead, and thus sets another rhythmic series in motion" (ibid., pp. 51–2).

41. Senghor, "What the Black Man Contributes," p. 288.

42. For example, in his article "L'esthétique négro-africaine" in *Diogène* (October 1956), he writes: "European reason is analytical by utilization, Negro reason is intuitive by participation" (see Senghor, *Liberté 1*, p. 203). This reprise is not a simple variant of the 1939 formula which remains an analogy.

43. *Khagneux* is someone who attended the preparatory school for the entrance examination into the École normale supérieure; *agrégé de grammaire* means that he succeeded in the competitive test to qualify as a teacher of grammar.

44. Evidence of this book's importance in Senghor's aesthetic reflections is found in a talk he gave in 1969, in which he mentions the contrast established by Guillaume and Munro between desirable forms and what we may call energy accumulators: "Looking at the *Venus de Milo*, the Greeks must have had a materialist reaction (I distinguish this from a sensual one), an intellectual reaction, dreaming of having such a woman: tall, with long muscles, finely shaped and blonde at that. Contemplate, now, the *Venus of Lespugue*. At first glance, it is not a woman, it is a bunch of shapes: spheric ones, oval ones, cylindrical ones, responding to each other without repeating...the *Venus of Lespugue* is an image but it is, first and foremost, a collection of rhythms. There is no wish, even among Negroes, to have a woman thusly shaped. But the rhythm, the rhythms of the image grab you. It is like sudden fulguration: a punch to the stomach that is able to provoke a sort of sensual, mystical surge. We are, at this point, quite far from an abstract and sterile eroticism, are we not?" (Léopold Sédar Senghor, "De la negritude" in *Liberté 5*, p. 22). Earlier, in the same talk, he says of the *Venus de Milo*: "What we have here is a woman in the world, in flesh and blood: she represents nothing more than herself. Never has the expression 'in flesh and blood' been more appropriate" (ibid., p. 21). How can we avoid hearing an echo here of what Guillaume and Munro wrote concerning what would be "humanly desirable in flesh and blood"?

45. Guillaume and Munro, *Primitive Negro Sculpture*, p. 16.

46. Here is how Senghor dates and presents the meaning of the en-
counter with Frobenius' books "among those books that were
sacred for a whole generation of black students":

> I cannot do better than to speak here of the les-
> sons we have learned from reading the work of Leo
> Frobenius, and above all his two fundamental works,
> which have also been translated into French: *Histoire
> de la civilisation africaine* [The History of African
> Civilization] and *Le Destin des Civilisations* [The
> Destiny of Civilizations]. When I say "we," I refer
> to the handful of black students who launched the
> Negritude movement in the 1930s in the Quartier
> Latin, in Paris, with Aimé Césaire from the Antilles
> and Léon Damas from Guyana. I still have before
> me, in my possession, the copy of the *Histoire de
> la civilisation africaine* on the third page of which
> Césaire wrote: "décembre 1936." A year earlier, when
> I was teaching at the Tours Lycée while preparing
> my doctor's thesis on "Verbal Forms in Languages
> of the Senegal-Guinea group"...I had started to at-
> tend courses at the Paris Institute of Ethnology and
> at the Practical School of Advanced Studies. So I
> was intellectually on familiar terms with the great-
> est Africanists and above all the ethnologists and lin-
> guists. But suddenly, like a thunderclap—Frobenius!
> All the history and pre-history of Africa were illu-
> minated, to their very depths. And we still carry the
> mark of the master in our minds and spirits, like a
> form of tattooing carried out in the initiation cer-
> emonies in the sacred grove (Léopold Sédar Senghor,
> "The Lessons of Leo Frobenius" in Eike Haberland
> (ed.), *Leo Frobenius, 1873–1973: An Anthology*
> [Wiesbaden: F. Steiner, 1973], p. vii).

See also Léopold Sédar Senghor, "Négritude et germanité I"
(1968, Negritude and Germany I) in *Liberté 3*, p. 13.

47. Leo Frobenius, *Der Ursprung der afrikanischen Kulturen* (Berlin: Gebrüder Borntraeger, 1898). Available in French as: *Histoire de la civilisation africaine* (H. Back and D. Ermont trans.) (Paris: Gallimard, 1936). Here, p. 16.

48. Ibid., pp. 17–18.

49. Guillaume and Munro, *Primitive Negro Sculpture*, p. 11.

50. Frobenius claims that whereas the Homeric Greeks knew how to look at the life of Ethiopians (for him, as for the ancients, this is a synecdoche for "Africans"), the distinction between "Romans" and "Barbarians" establishes the European habit of taking strangers out of representation; the divisions between Christians and pagans and then civilized and savages reinforce this habit. "It was necessary for these human beings to be first completely eliminated from our European concerns in order for them to newly leap into our view, coming suddenly out of their invisibility, and appearing to us as our antagonists" (Frobenius, *Histoire*, p. 29).

51. Senghor, "What the Black Man Contributes," p. 296.

52. Senghor, "L'esthétique négro-africaine," pp. 211–12.

53. Ibid., p. 213.

54. Guillaume and Munro, *Primitive Negro Sculpture*, p. 59.

55. Ibid., p. 49.

56. Ibid., pp. 51–2 (emphases added).

57. Léopold Sédar Senghor, "Lettre à trois poètes de l'hexagone" (Letter to three Poets of the hexagon) in *OEuvre poétique* (Paris: Editions de Seuil, 1990), p. 371.

58. Bell, *Art*, p. 59.

59. Ibid.

60. Ibid., p. 57.

61. Placide Tempels, *Bantoe-filosofie* (Antwerp: De Sikkel, 1946). Available in French as: *La philosophie bantoue* (A. Rubbens trans.) (Elizabethville: Lovania, 1945). Available in English as *Bantu Philosophy* (Colin King trans.) (Paris: Présence Africaine, 1959).

62. Léopold Sédar Senghor, "Le Musée dynamique" (1966, The Dynamic Museum) in *Liberté 3*, p. 66.

63. Apostel, *African Philosophy*, pp. 26–9.

64. All forces are radically interdependent in an internal way (actions are thus in no way "magic": when we come to consider this

universe of forces, we see that they are exercised either between forces of the same rank or from a superior to an inferior one).

65. The action can also be indirect and involve the use of beings of lower rank to act upon a being of equal rank.

66. Apostel, *African Philosophy*, p. 325.

67. Léopold Sédar Senghor, "Comme les lamantins vont boire à la source" (1960, As the Manatees Drink at the Source) in *Liberté 1*, p. 222.

68. Sartre, *Black Orpheus*, p. 37.

69. Léopold Sédar Senghor, "Réponse à la poseuse d'énigmes" (1973, A Response to the Riddle-Asker) in *Liberté 3*, pp. 396–7.

70. I employ here the very useful concepts of Renée Tillot, who calls *primitive* or *inner rhythm* the rhythmical movement as the thing itself that resonates with the sensitivity of the artist and *transcribed rhythm* that which is re-created by the artist. See Renée Tillot, *Le rythme dans la poésie de Léopold Sédar Senghor* (Dakar: Les Nouvelles Éditions Africaines, 1979).

71. When he analyzes African murals (in particular, those reproduced in *Paredes Pintadas da Lunda*) and stresses the rhythmic series created by colors that are, as he specifies, "always flat, without shadow effects," Senghor writes with an obvious concern for his paradoxical formula: "[R]hythm is even more obvious in Negro-African *painting*" ('L'esthétique négro-africaine," p. 215). Furthermore, the novelist and poet Seghers Nimrod was right to say, in his profoundly true formulation, that "Senghor is not a poet of the tom-tom" (meaning that Senghor does not fall into the ease of producing drumming effects in his poetry). See Seghers Nimrod, *Le tombeau de Léopold Sédar Senghor* (The Tomb of Leopold Sédar Senghor) (Paris: Le Temps qu'il fait, 2003), p. 62.

72. Senghor, "L'esthétique négro-africaine," p. 214.

73. *A Season in Hell*, first translated into English in 1932. Available, in one of many English translations, in Arthur Rimbaud, *Collected Poems* (Martin Sorrell trans.) (Oxford, UK: Oxford University Press, 2001), pp. 210–55.

74. Ibid., p. 219. [Translation modified. Whereas Sorrell and others translate "*nègre*" as "nigger," a word whose violence is appropriate in the context of *A Season in Hell*, I have opted to maintain

continuity with my usual rendering of the word as "Negro" given the focus on Senghor's investment in this passage.—Tr.]

75. Senghor, "Lettre à trois poètes," p. 372. Senghor cites here passages from *A Season in Hell* taken from the sections "Bad Blood" and "Alchemy of the Word." See Rimbaud, *Collected Poems*, pp. 219, 235.

76. Senghor, "Lettre à trois poètes," p. 375. The analogical image is not one fixed in the immobility of representing an original (an image-equation, as Senghor puts it) but an image with which the rhythm of the original is consubstantial and which thus holds its "power."

77. "For what reason, in the 1930s, did we, the militants of Negritude, call Claudel and Péguy "our Negro poets"? along with the Surrealists, they influenced us—incidentally, less than people have said—because they wrote in French but yet resembled, in style, our popular poets" (Senghor, *Oeuvre poétique*, p. 377).

78. Frobenius, who saw a deep affinity between Africanity (which he called, in the manner of the ancients, "Ethiopianity") and a German mystical spirit (which Senghor will christen "Germanity") influenced him a great deal in this approach.

79. Senghor, *Ce que je crois*, p. 218.

80. Senghor, "L'esthétique négro-africaine," p. 216.

CO-NAISSANCE

1. Léopold Sédar Senghor, "Les nationalismes d'outre-mer et l'avenir des peuples de couleur" (1959, Overseas Nationalisms and the Future of Peoples of Color) in *Liberté 2: Nation et voie africaine du socialisme* (Paris: Editions du Seuil, 1971), p. 278.

2. Henri Gouhier, in his introduction to Bergson's collected works, indicates that Bergsonism is the end of Cartesianism. See Henri Gouhier, "Introduction" in Henri Bergson," *Oeuvres*, 3rd edn (Paris: Presses Universitaires de France, 1970).

3. René Descartes, *Discourse on Method*, 3rd edn (Donald A. Cress trans.) (Indianapolis, IN: Hackett Publishing Company, 1998), p. 4.

4. Paul Valéry, "Funeral Address on Bergson" in *The Collected Works of Paul Valéry, Volume 9: Masters and Friends* (Martin

Turnell trans., Jackson Matthews ed.) (Princeton, NJ: Princeton University Press, 1968), p. 304.

5. Aristotle, *Physics* 219B.

6. Bergson, *Time and Free Will*, p. 115.

7. Descartes, *Discourse on Method*, p. 35.

8. Bergson, *Creative Evolution*, p. 358.

9. Ibid., p. 52.

10. Ibid., p. 53.

11. Ibid., pp. 182, 194.

12. Léopold Sédar Senghor, "Négritude et modernité ou la Négritude est un humanisme du XXe siècle" (1970, Negritude and Modernity or Negritude as a Humanism for the Twentieth Century) in *Liberté 3*, p. 219.

13. Following the path traced by Tempels' *Bantu Philosophy*, Alexis Kagamé, relying on the study of several Bantu languages, pursued the project of drawing up such categories on the basis of the idea (which he expressed before Emile Benveniste) that the categories of thought established by Aristotle are, ultimately, nothing but grammatical categories of the Greek language. See Alexis Kagamé, *La philosophie bantu-rwandaise de l'être* (The Bantu-Rwandese Philosophy of Being) (Brussels: Académie royale des sciences coloniales, 1956), 8 vols.

14. Bergson, *Creative Evolution*, pp. 291, 374.

15. Léopold Sédar Senghor, "Vues sur l'Afrique noir ou assimiler, non être assimilé" (1945, Views on Black Africa, or, To Assimilate, Not Be Assimilated) in *Liberté 1*, p. 42.

16. Available in English in Lilian A. Clare's translations as *How Natives Think* (Princeton, NJ: Princeton University Press, 1985 [1926]); *Primitive Mentality* (London: George, Allen and Unwin, 1923); *The "Soul" of the Primitive* (London: George, Allen and Unwin, 1928).

17. Available in English as *The Philosophy of August Comte* (Kathleen Mary de Beaumont Klein trans.) (London: S. Sonnenschein Co., 1903); *Ethics and Moral Science* (Elizabeth Lee trans.) (London: A. Constable & Co, 1905).

18. Georges Davy, *L'homme, le fait social et le fait politique* (Man, Social Fact, and Political Fact) (Paris: La Haye/Ecole pratique des hautes études/ Mouton, 1971), p. 167. On the way in which

Lucien Lévy-Bruhl was led to the question of "primitive mentality," see Frédéric Keck's doctoral thesis, *Le problème de la mentalité primitive : Lévy-Bruhl entre philosophie et anthropologie* (available at www.univ-lille3.fr/-theses/keckfrederic/html/these.html)

19. Lucien Lévy-Bruhl, "La mentalité primitive. Séance du 15 Février 1923. Compte rendu" (Primitive Mentality; February 1923 session: A report), *Bulletin de la Société française de philosophie* 23 (15 February 1923): 23. Also cited in Davy, *L'homme*, p. 166.

20. In the same issue of the *Bulletin de la Société française de philosophie* in which the piece by Lévy-Bruhl appeared, we read this critique by Marcel Mauss: "People speak of primitives but, in my view, only the Australians, the sole survivors of the Paleolithic age, merit this name. All the American and Polynesian societies are in the Neolithic age and are agricultural; all the African and Asian societies have already surpassed the Stone Age and are agricultural and have domesticated animals. It is thus impossible from any point of view to arrange these societies on the same plane" (quoted in Davy, *L'homme*, p. 169). Evidently Mauss does not put into question the very notion of primitiveness and does not say here that the societies that collectively form humanity at a given moment, whatever their degree of technological advancement, are quite simply *contemporaries* in the same age; he simply objects to what seems to him, and rightly so, a methodological error.

21. Available in English as *Primitives and the Supernatural* (Lilian A. Clare trans.) (New York: E. P. Dutton, 1935), p. 8.

22. Alain de Benoist, *Europe, Tiers monde, même combat* (Europe, Third World: Same Struggle) (Paris: R. Laffont, 1986).

23. Lévy-Bruhl, *How Natives Think*, p. 29.

24. Davy, *L'homme*, p. 166.

25. In the second chapter—"La philosophie analytique à partir de l'anthropologie" (From Anthropological Perspective to Analytic Philosophy)—of his doctoral thesis, Keck revisits the way in which "Lévy-Bruhl's reasoning, which consists of beginning from astonishment at the nonsense of an utterance to undertaking an anthropological analysis of other utterances, has

been able to interest (analytic philosophy)." He evokes, in particular, the way in which "Quine establishes a new relationship between philosophy and anthropology in analytic philosophy." The idea of the universal meaning of an utterance is, according to him, a "philosophical myth that can be dispelled by an empiricist reflection inspired by anthropology, which confronts this 'myth' with the situation of the anthropologist encountering an utterance that has no immediate meaning for him."

26. Davy, *L'homme*, p. 180.

27. Available in English as: *The Notebooks on Primitive Mentality* (Peter Rivière trans.) (Oxford: Basil Blackwell, 1975).

28. Thus Hymans writes in *Léopold Sédar Senghor* that "Senghor found another aspect of the Negro soul in reading the works of Lévy-Bruhl," having been thus led to contrast a Negro reason which is "intuitive by participation" with European analytic reason (p. 67). In the appendix to this book, Hymans reproduces a review of his intellectual biography of Senghor, written in January 1965 by one of the historic leaders of the African student movement, at the time that it was a doctoral thesis presented to the Sorbonne. The article, signed "Diogomaye" (the *nom de plume* of Senegalese philosopher Amady Ali Dieng), regrets, among other things, that the influence of the philosopher-ethnologist has not been studied earlier and in a more critical manner.

29. Senghor, "Vues sur l'Afrique noire, ou assimiler non être assimilés," p. 42 (emphasis in the original). In December 1967, in a speech at the 2nd International Congress of Africanists held in Dakar, he will declare, as a criticism of those who believe on principle in a methodological differentialism according to which Europe and Africa are to be studied: "I fear that some, even among Africans, still believe in the 'prelogical mentality' of Lévy-Bruhl, even though he courageously renounced it before his death..." See Léopold Sédar Senghor, "L'Africanisme" (1967) in *Liberté 3*, p. 168. It is surprising that, in his celebrated polemic against Negritude, *Négritude et négrologues* (Negritude and Negrologists) (Paris: Le Castor Astral, 1998), Stanislas S. Adotevi ignores Senghor's very words regarding Lévy-Bruhl. Speaking of the latter's influence on the former, Adotevi writes

that Senghor "repeats to the letter, in an almost scholarly manner, that which Lévy-Bruhl, the father of primitivism, himself denounced in his *Notebooks* as mistakes." Quoting after this a passage by Lévy-Bruhl in which he speaks of the primitive, Adotevi comments: "Let us remove 'primitive.' Replace it with the word 'Negro' and we obtain, to the point of plagiarism, the development of the unforgettable sentence of Senghor: 'Emotion is Negro as reason is Hellenic.'" Adotevi then believes he can conclude his commentary with these words: "Senghor has read Lévy-Bruhl, it is clear. It is even certain" (*Négritude*, pp. 49–50). The rule of polemical writing is certainly to not be very careful when it comes to paying attention to what the person being critiqued really said; all the same, this does not explain why Adotevi presents the fact that Lévy-Bruhl is quite present in Senghor's thought and that "it is even certain" that the latter read him as a discovery that might have escaped the less informed reader! This presence is in no way clandestine; it is Senghor himself who evokes it, even while explaining his opposition to the prelogical thesis. It is even more surprising to see Adotevi write that Senghor "consequently knew of (but probably rejected) the *Notebooks* and the extraordinary honesty of this man who, in the middle of his official fame, while primitivism was all the rage in colonialist and exquisitely reactionary circles, was not afraid to reconsider it all, thus destroying the work of his life" (p. 50). As we see in the above quote, Senghor did not "probably" reject the *Notebooks*; he himself discussed them as early as in 1945.

30. Bergson, *Creative Evolution*, pp. 291–2.
31. These articles can be found in *La Revue du Monde noir, 1931–1932* on pp. 242–3 and 300–02, respectively. Hymans informs us of having learned from Paulette Nardal herself that it was Baye-Salzmann who inspired Senghor's distinction between a "Dionysian" Africa and an "Apollonian" Europe. See Hymans, *Léopold Sédar Senghor*, pp. 41, 226n26.
32. Baye-Salzmann, "Negro Art," p. 302 (translation modified).
33. Bergson, *Time and Free Will*, p. 111.
34. Abiola Irele writes that "it is not surprising that Senghor's theory of the African's method of knowledge and his aesthetic

theory should be intimately related, and even coincide" (Abiola Irele, *The African Experience in Literature and Ideology* [Bloomington, IN: Indiana University Press, 1990], p. 75). Indeed, they coincide.

35. Bergson, *Creative Evolution*, pp. 194–5 (translation modified).
36. Baye-Salzmann, "Negro Art," pp. 300–01 (translation modified).
37. Senghor, "Les nationalismes d'outre mer et l'avenir des peuples de couleur," pp. 277–8: "Instead of bringing the object to the subject, intuitive reason integrates the subject into the object; to be more precise, the subject and object identify with each other, which is the true mode of knowledge. This is why art is not, in black Africa, imitation of appearances or diversion, but a means of knowledge—the most efficient means. To the civilization of division that is Europe's, Africa thus opposes the civilization of creative unity."
38. Senghor, "L'esthétique négro-africaine," p. 209.
39. Bell, *Art*, p. 4.
40. "This is…another character of the poem (again, I mean by 'poem' any work of art): *it is made by all and for all.* Certainly there are professionals of literature and art: in the Sudanian countries, the *griots*, who are at once chroniclers of history, poets and storytellers; in the countries of Guinea and the Congo, civilian sculptors in the princely courts, for whom the adze on the shoulder is a badge of honor; everywhere, the blacksmith, who is an engineer of magic and art and, according to a Dogon myth, the first artist, who made rain fall from the sky with the rhythm of the tam-tam. However, beside these professionals, there is the people, the anonymous crowd that sings, dances, sculpts and paints." Senghor, "L'esthétique négro-africaine," p. 207.
41. Ibid.
42. Senghor, "Négritude et modernité," p. 239. Sartre wrote: "We shall call emotion an abrupt drop of consciousness into the magical." See Jean-Paul Sartre, *The Emotions: Outline of a Theory* (Bernard Frechtman trans.) (New York: Wisdom Library, 1948), p. 90.
43. Senghor, "Négritude et modernité," p. 239.

44. Ibid., pp. 239–40.

45. Senghor returns to this aspect of the "Revolution of 1889" in a systematic manner in his "Preface" to Alassane Ndaw's *La pensée africaine* (Dakar: Les Nouvelles Éditions Africaines, 1983).

46. Léopold Sédar Senghor, "La voie africaine du socialisme: nouvel essai de définition" (1960, The African Path to Socialism: A New Attempt at a Definition) in *Liberté 2*, p. 287. The Picon text that Senghor quotes is the "Introduction" to his *Panorama des idées contemporaines* (Panorama of Contemporary Ideas) (Paris: Gallimard, 1957). On the placing in question of objectivity by new science, Senghor also refers his readers to Gaston Bachelard, *The New Scientific Spirit* (Arthur Goldhammer trans.) (Boston: Beacon Press, 1984).

47. "This knowledge by means of confrontation and intuition is, upon a close look, Negro African knowledge" (Senghor, "La voie africaine du socialisme," p. 288).

48. "Each people preferring this or that form of reasoning, but above all this or that expression, human thought remains identical to itself on all the continents and among all the races, ethnic groups and nations" (Léopold Sédar Senghor, "Pour une philosophie négro-africaine et moderne" [1983, For a Negro African and Modern Philosophy] in *Liberté 5*, p. 220).

49. *Revue Philosophique de la France et de l'Etranger* 4 (October–December 1957).

50. For example, in his 14 November 1934 letter to E. E. Evans-Pritchard (who had just published an article on "Lévy-Bruhl's Theory of Primitive Mentality" in the *Bulletin of the Faculty of Arts*), he admits to having "been wrong in insisting so strongly on [. . .] differences" and he indicates that he agrees with the British anthropologist that "[s]avage thought has not the fixed inevitable construction that [he] gives it." Lucien Lévy-Bruhl, "A Letter to E. E. Evans-Pritchard," *The British Journal of Sociology* 3 (June 1952): 119, 122.

51. In notes written for the conclusion of a series of lectures, he declared: "Reject any curt, absolute thesis and respect the nuances of reality, which is complex and *many sided...*" (cited in Schuhl, *Revue Philosophique*, p. 39).

52. Emmanuel Levinas, "Lévy-Bruhl and Contemporary Philosophy" in *Entre-nous: On Thinking-of-the-Other* (Michael B. Smith and Barbara Harshav trans.) (New York: Columbia University Press, 1998), p. 40. Once it is no longer associated with a different "humanity," Levinas shows how much "primitive mentality" proves to be a notion that serves to put in question "the supposed necessity of...categories for the possibility of experience" (p. 40), allowing us to think in another way about the philosophical notion of "representation" [namely, to see it as linked to "the "intentionality" of emotion" (p. 43)], and to envisage the destruction of "the substantiality" of beings" (p. 47) whose existence, instead of being "colorless and neutral," will then be "deployment,...effectiveness, influence, control, and transitivity" (p. 48).

53. Pierre-Maxime Schuhl, "Hommage à Lévy-Bruhl," *Revue philosophique* 147 (1957): 398–403. Here, p. 399.

54. Sartre, *Emotions*, pp. 52, 90. Sartre writes on the latter page: "the word can also appear...as a non-instrumental totality, that is, modifiable by large masses and without intermediary. In this case, the categories of the world will act upon consciousness immediately. They are present to it *without distance*." The Sartrean notion of emotion as apprehension of reality or of "noninstrumental totality" greatly influences Senghor's thought.

55. Philippe Laburthe-Tolra, *Critique de la raison ethnologique* (Critique of Ethnological Reason) (Paris: Presses Universitaires de France, 1998), p. 105.

CONVERGENCE

1. Senghor, "La voie africaine du socialisme," p. 284

2. Léopold Sédar Senghor, "Lettre à Gunter Grass" (1968) in *Liberté 3*, pp. 174–9.

3. Ibid., p. 177.

4. Similarly, Jean-Luc Nancy contrasts, on one hand, *globalization*, "to speak English," he says, designating the movement "whose law is nothing other than the growing concentration of wealth and decision-making power" and, on the other, *mondialisation*, "to speak French," evoking "the possibility not of a round globe but of a world [*un monde*], that is to say, a space of

possible meaning." See Jean-Luc Nancy, "Preface" in Mustapha Chérif, *L'islam, l'autre et la mondialisation* (Islam, the Other and Globalization) (Algiers: Anep, 2005), pp. 7–8.

5. See Edmund Husserl, *The Crisis of European Sciences and Transcendental Phenomenology* (Evanston, IL: Northwestern University Press, 1970).

6. Pierre Teilhard de chardin, quoted in Léopold Sédar Senghor, "Hommage à Pierre Teilhard de Chardin" (1963) in *Liberté 5*, p. 13.

7. Ibid.

8. The speech he made on this occasion is reproduced as "L'Unesco" in *Liberté 1*, pp. 308–11.

9. Ibid., p. 310.

10. See, for example, Hymans, *Léopold Sédar Senghor*, pp. 12–14; Joseph Roger de Benoist, *Léopold Sédar Senghor* (Paris: Beauchesne, 1998), pp. 15–20; Janet Vaillant, *Black, French, and African: A Life of Léopold Sédar Senghor* (Cambridge, MA: Harvard University Press, 1990), p. 59; Jacqueline Sorel, *Léopold Sédar Senghor, l'émotion et la raison* (Paris: Sépia, 1995), pp. 32–6.

11. Quoted in de Benoist, *Senghor*, p. 18.

12. This is how Senghor came to transfer from the seminary to the secular secondary school where he obtained the baccalaureate two years later.

13. Thus Jean Toussaint Desanti writes: "The problem as a whole is to see to it that between one community and another there would be relations of opening and closure: relations of closure that must effectively preserve reflexivity about group and identity, but closure does not signify exclusion; a relation of opening, that is to say, a relation such that each member of a community thus linked can say to themselves that insofar as you, you who are in another community, you are what you feel in your community, you want what you want for your community, then I by the same token and in the same movement am called to interest myself in your community and you are called to interest yourself in mine; we are called to construct and weave effectively lived connections, effectively human connections, and not abstract connections which, in fact, will never be anything

other than the connections of the market." See Jean Toussaint Desanti, "Négritude au-delà" (Beyond Negritude) in Annick Thébia-Melsan and Gérard Lamoureux (eds.), *Aimé Césaire, pour regarder le siècle en face* (Aimé Césaire: In Order to Face the Century) (Paris: Maisonneuve & Larose, 2000), pp. 54–5.

14. See the chapter entitled "Spokesman" in Vaillant, *Black, French, and African*, pp. 147–65.

15. Léopold Sédar Senghor, "Le problème culturel en A.O.F." (1937, The Cultural Problem in A.O.F) in *Liberté 1*, pp. 14, 19.

16. Ibid., p. 21. [Brent Hayes Edwards discusses differences between Senghor's translation and Claude McKay's original lines as found in his novel *Banjo* in *The Practice of Diaspora: Literature, Translation, and the Rise of Black Internationalism* (Cambridge, MA: Harvard University Press, 2003), pp. 188, 362n8; I have used Edwards' translation of Senghor's version.—Tr.]

17. Vaillant, *Black, French, and African*, p. 155.

18. Léopold Sédar Senghor, "Préface" in Paul Coulon and Paule Brasseur (eds.), *Liberman 1802–1852: Une pensée et une mystique missionnaires* (Paris: Le Cerf, 1988), pp. 9–10.

19. Paul Coulon's precise and well-researched article "Léopold Sédar Senghor, the Spiritans and Libermann" quotes this passage from a radio interview with Senghor by Edouard Maunick in 1976 in which he declares, speaking of his school days: "So then I revolted against the assertions of P. Lalouse, who was a saint (he is currently, by the way, at La Trappe), against the assertions according to which there was no Negro African civilization." See Paul Coulon, "Léopold Sédar Senghor, les spiritains et Libermann" in *Mémoire spiritaine* 15 (2002): 132.

20. Sorel, *Senghor*, p. 46.

21. Senghor, "Hommage à Pierre Teilhard de Chardin," p. 9.

22. In his essay "Pourquoi une idéologie négro-africaine?" (Why a Negro African Ideology?), given in Abidjan in 1971 as a speech of gratitude for an honorary degree from the Ivorian capital's university, Senghor says that "from my days in the Latin Quarter, I always wished to be a democratic socialist" before dedicating an important part of his essay to showing that Maoism too cannot be understood as anything other than a

rereading of Marxism-Leninism according to the Chinese spirit and civilization.

23. Senghor, "Hommage à Pierre Teilhard de Chardin," p. 11. Irele rightly characterizes the influence of Telhard de Chardin on Senghor's socialism: ". . . Senghor's African socialism marks a break with Marxist theory, turning rather to the philosophy of Pierre Teilhard de Chardin for its inspirational groundwork. The exact connection between socialism and Teilhard de Chardin's philosophy is not easy to grasp, but its fascination for Senghor can be explained on three closely related counts. Firstly, it offers a prospective ideal almost as impressive as Marxism, with the added advantage of being grounded in an appealing scientific theory. Secondly, Teilhard de Chardin's theory of convergence— the progressive development of a higher form of consciousness from all forms of life and experience —offers scope for the participation of African values in a universal civilization. Thirdly, Teilhard de Chardin restores in his vision of man the spiritual dimension which Senghor considered lacking in Marxist philosophy. His reconciliation of science with religion, which was felt as liberating influence by Catholic intellectuals, may also have appealed to Senghor, who is himself a Catholic" (Irele, *The African Experience in Literature and Ideology*, p. 79).

24. Ibid.

25. "Instinctively, in their attempts to make an intellectual scheme of the Universe, many men try to use Matter as their *starting point.* Because Matter can be touched, and because it *appears* historically to have existed first, it is accepted without examination as the primordial stuff and most intelligible portion of the Cosmos. But *this road leads nowhere.*" Pierre Teilhard de Chardin, "The Spirit of the Earth" in *Human Energy* (J. M. Cohen trans.) (London: Collins, 1969), p. 22 (translation modified).

26. Ibid., p. 23.

27. Ibid.

28. Ibid., p. 29.

29. Ibid., p. 30.

30. Ibid., p. 31.

31. Donna V. Jones has devoted a very enlightening book to the centrality of the life philosophy to Negritude, Senghor's

in particular (Donna V. Jones, *The Racial Discourses of Life Philosophy. Négritude, Vitalism, and Modernity* (New York: Columbia University Press, 2010). When this book was first published in French Donna Jones' work did not exist; that is why it is not present in this translation.

32. Senghor, "Hommage à Pierre Teilhard de Chardin," pp. 12–13.
33. The essay, entitled "Pour une cooperation entre l'islam et le christianisme" (Towards Cooperation Between Islam and Christianity) was reprinted in *Liberté* 1, pp. 304–07. The chronological organization of Senghor's theoretical writings makes it so that the essay is found there. Thematically, it belongs instead in the fifth collection, which is justly subtitled *Le Dialogue des Cultures* (The Dialogue of Cultures).
34. Ibid., p. 307.
35. Ibid., pp. 305–06.
36. Ibid., p. 306. [I have used the familiar King James version of the quote from the Bible but it is significant to note that the word "righteousness" here is *la justice* (justice) in French; similarly, I have used a popular translation of the Quran (the Yusuf Ali version) but it is important to note that a literal rendering of the French would be "God does not improve a people's situation before this people improves its soul."—Tr.]
37. Senghor speaks of these questions of the modernity of the Christian and Muslim religions in his June 1959 Report to the Constitutive Congress of the Party of the African Federation, printed in English as *African Socialism* (Mercer Cook trans.) (New York: American Society of African Culture, 1959), p. 28.
38. Faure's speech was printed in the 30 March 1984 issue of *Le Monde*.
39. Edgar Faure, "*Réponse de M. Edgar Faure au discours de M. Léopold Sédar Senghor.*" Available online at: www.academie-francaise .fr/ Immortels/discours_reponses/faure2.html [I have used the English translation of Iqbal's "The Three States in the Education of the Self" in *The Secrets of the Self* (Reynold A. Nicholson trans.). Available online at www.sacredtexts.com/-isl/iq/iql2 .htm —Tr.]
40. In these times in which religious fundamentalists believe it possible to recommence the assault on evolution, it is good to

re-read Teilhard de Chardin: "Is evolution a theory, a system or a hypothesis? It is much more: it is a general condition to which all theories, all hypotheses, all systems must bow and which they must satisfy henceforward if they are to be thinkable and true. Evolution is a light illuminating all facts, a curve that all lines must follow [. . .] Until that time the world seemed to rest, static and fragmentable, on the three axes of geometry. Now it is a casting from a single mould. What makes and classifies a 'modern' man (and a whole host of our contemporaries is not yet 'modern' in this sense) is having become capable of seeing in terms not of space and time alone, but also of duration, or—it comes to the same thing—of biological space-time; and above all having become incapable of seeing anything otherwise—anything—*not even himself*." See Pierre Teilhard de Chardin, *The Phenomenon of Man* (Bernard Wall trans.) (New York: Harper Colophon, 1959), p. 219.

41. Senghor, "Hommage à Pierre Teilhard de Chardin," pp. 11–12.
42. Muhammad Iqbal, *L'aile de Gabriel* (Mirza Saïd uz-Zafar Chagtaï and Suzanne Bussac trans.) (Paris: Albin Michel, 1977), p. 104. Another essential convergence between Jesuit father Teilhard de Chardin and Iqbal is the idea that the goal is not to see and contemplate but to be, through action. Teilhard de Chardin claimed that what is necessary is "*increased action for increased being*" and this perfectly sums up the Iqbalian philosophy of action. See Teilhard de Chardin, *The Phenomenon of Man*, p. 249.
43. Emmanuel Levinas, *Humanism of the Other* (Nidra Poller trans.) (Urbana, IL: University of Illinois Press, 2003), p. 37.
44. Ibid.
45. Mirza Saïd uz-Zafar Chagtaï, "Introduction" in Iqbal, *L'aile de Gabriel*, pp. 22–3. For more on Iqbal as thinker of emergent cosmology and panhuman convergence, see Souleymane Bachir Diagne, *Islam and the Open Society: Fidelity and Movement in the Philosophy of Muhammad Iqbal* (Melissa McMahon trans.) (Dakar: Codesria, 2011).
46. Senghor reproduces only the second part of the report in *Liberté 2* as "Nation et socialisme" (Nation and Socialism) (pp. 232–70). Is this because the first part is really more

"communist" than "socialist"? The American Society of African culture published the report in its entirety in English as *African Socialism*.

47. Senghor, "La voie africaine du socialisme," p. 314.
48. Senghor writes, for example: "Marx gradually placed more and more stress on materialism, means, and *praxis* (practice), while the philosophical thought and ethical concerns of his earlier works were toned down. But, although de-emphasized and hidden, they did not disappear completely... we may say that they underlie Marx's writings" (Senghor, *African Socialism*, p. 21).
49. Senghor, "Marxisme et humanisme" (1948) in *Liberté 2*, p. 31.
50. Senghor cites this celebrated passage from Marx near the beginning of his 1956 report "Socialisme et culture" (Socialism and Culture) in *Liberté 2*, p. 185. he notes that the emphasis is his. See Karl Marx, "Economic and Philosophical Manuscripts of 1844" in Robert C. Tucker (ed.), *The Marx-Engels Reader*, 2nd edn (New York: W. W. Norton & Company, 1972), p. 76.
51. Senghor, "Marxisme et humanisme," p. 22. Senghor adds that the same can be affirmed of Islam.
52. Jacques Maritain, *Integral Humanism* (Joseph W. Evans trans.) (New York: Charles Scribner's Sons, 1968), p. 2. Quoted in Senghor, "Marxisme et humanisme," p. 30.
53. The letter is reproduced in Paul Coulon, "Léopold Sédar Senghor, les spiritains et Libermann" in *Mémoire Spiritaine* 15 (1st quarter 2002): 128. It was previously unpublished, conserved in the Congregation's archives under Arch.cSSp 264-B-X. It is interesting to note that the letter's primary purpose is a protest by Senghor in light of a situation in which the unwillingness of white missionaries to accept a black apostolic prefect in the form of Monsignor Joseph Faye, a childhood friend of Senghor's, pushed Faye to resign before choosing a contemplative life. Senghor ends his letter with this: "To conclude on a concrete matter, it is essential that the new bishop to be named in Senegal accepts the revolution brought by the new Constitution; this will be the best way to work for Catholicism." The irony is that the "new bishop" in question will be Monsignor Lefebvre, whose "integrist" career is

well-known and in whom anticommunism and Islamophobia always went together.

54. Senghor, "Socialisme et culture," p. 188.
55. Ibid., p. 186.

CONCLUSION

1. Léopold Sédar Senghor, "Chacun doit être métis à sa façon ou l'université Gaston Berger" (1975, Everyone Must be Mixed in their Own Way or Gaston Berger University) in *Liberté 5*, p. 46.
2. "Our friend Wole Soyinka throws this at us: 'A tiger does not speak of his tigritude.' To this I respond: a tiger does not speak of his tigritude because he is a beast. Man, however, speaks of his humanity because he is man and he thinks" (Léopold Sédar Senghor, "Qu'est-ce que la Négritude?" [1967] in *Liberté 3*, p. 101).
3. See "DNA Tells Students They Aren't Who They Thought" in *The New York Times*, 13 April 2005. In the 30 July issue of the same year, an article ("Debunking the Concept of Race") returns to Prof. Samuel Richards' usage of the results of this type of tests to "shake students out of rigid and received notions about the biological basis of identity. By showing students that they aren't what they think they are, he shows them that race and ethnicity are more fluid and complex than most of us think. The goal is to make students less prejudiced and more open to a deeper discussion of humanity."
4. Nicole Bacharan, *Faut-il avoir peur de l'Amérique?* (Should We Fear America?) (Paris: Editions du Seuil, 2005), p. 143.
5. In a long letter dated 8 October 1970, addressed to his American biographer Vaillant, Senghor claims "Negritude is not an essence" but "a phenomenon" in the sense, he clarifies, that Teilhard de Chardin uses the word, or, he adds, "if you prefer, in the Sartrean sense of the word, an *existence*." I thank Janet Vaillant for having given me the gift of a copy of her written correspondence with Senghor.
6. Senghor, "Chacun doit être métis," p. 49.
7. Léopold Sédar Senghor, "Gaston Berger ou le philosophe de l'action" (1962, Gaston Berger or the Philosopher of Action) in

Liberté 1, p. 382. While Berger was on an official visit to Dakar as Director of Higher Education in France, he dedicated part of his speech to the "voyage home" that this trip to the country of his grandmother, where his father was born, represented for him. His son, choreographer Maurice Béjart, also happily notes that he is a son of the city of Saint-Louis in Senegal, where the local university bears Berger's name.

8. Senghor, "Chacun doit être métis," p. 48.

9. Towa, *Poésie de la negritude*, p. 269.

10. Léopold Sédar Senghor, "L'Afrique s'interroge: subir ou choisir?" (1950, Africa Ponders: To Bear or to Choose?) in *Liberté 1*, p. 92. [I have used the translation from Vaillant, *Black, French and African*, p. 145.—Tr.]

11. Léopold Sédar Senghor, "Asturias le métis" (1974, Asturias the Mixed Race) in *Liberté 3*, p. 507.

12. For example, the essay entitled "Du métissage biologique au métissage culturel" (From Biological to Cultural Mixture) in *Liberté 5*, pp. 110–23.

13. "This is the virtue of mixed civilizations. It is significant that the great civilizations were mixed. Prestigious names come to mind: Sumer, Egypt, Greece. Closer to us, Brazil, the USA and the USSR clarify our direction, our hope" (Senghor, "L'Afrique s'interroge," p. 91).

14. Léopold Sédar Senghor, "De la liberté de l'âme ou éloge du métissage" (On the Liberty of the Soul or in Praise of Mixture) in *Liberté 1*, p. 103.

15. Nimrod, *Le tombeau de Léopold Sédar Senghor*, 30–1. See Jean Bernabé, Patrick Chamoiseau and Raphaël Confiant, *Éloge de la créolité/In Praise of Creoleness* (bilingual edn; M. B. Taleb-Khyar trans.) (Paris: Gallimard, 1993). It begins: "Neither Europeans, nor Africans, nor Asians, we proclaim ourselves Creoles" (p. 75).

16. Guillaume and Munro, *Primitive Negro Sculpture*, p. 32.

17. In *Liberté 5* (pp. 43–5), for example, we find an essay entitled "Grèce antique et Négritude" (Ancient Greece and Negritude), which is the preface to Alain Bourgeois' *La Grèce antique devant la negritude* (Ancient Greece Faced with Negritude) (Paris:

Présence Africaine, 1971). Senghor repeats here the assertion of Paul Rivet, who was his professor at the Paris Institute of Ethnology: "There is between 4 and 20 percent black blood surrounding the Mediterranean."

18. Senghor, "Le dialogue des cultures," *Liberté 5*, p. 208.

BIBLIOGRAPHY

WORKS BY LÉOPOLD SÉDAR SENGHOR

1948. *Anthologie de la nouvelle poésie nègre et malgache: de langue française*. Paris: Quadrige/PUF.

1957. *Panorama des idées contemporaines*. Paris: Gallimard.

1959. *African Socialism* (Mercer Cook trans.). New York: American Society of African Culture.

1964. *Liberté 1: Négritude et Humanisme*. Paris: Éditions du Seuil.

1971. *Liberté 2: Nation et voie africaine du socialisme*. Paris: Editions du Seuil.

1977. *Liberté 3: Négritude et Civilisation de l'Universel*. Paris: Éditions du Seuil.

1980. *La poésie de l'action: conversations avec Mohammed Aziza*. Paris: Stock.

1983. *Liberté 4: Socialisme et planification*. Paris: Éditions du Seuil.

1988. *Ce que je crois*. Paris: Grasset.

1991. *The Collected Poetry* (Melvin Dixon trans.). Charlottesville and London: University Press of Virginia.

1993. *Liberté 5: Le Dialogue des Cultures*. Paris: Éditions du Seuil.

SECONDARY WORKS

Abraham, W. E. 1962. *The Mind of Africa*. London: Weidenfeld and Nicolson.

Adotevi, Stanislas. 1998. *Négritude et négrologues*. Paris: Le Castor Astral.

Apollinaire, Guillaume. 1972. *Apollinaire on Art: Essays and Reviews 1902–1918* (Leroy C. Breunig ed., Susan Suleiman trans.). New York: Viking Press.

Apostel, Leo. 1981. *African Philosophy: Myth or Reality?* Ghent: E. Story-Scientia.

Bacharan, Nicole. 2005. *Faut-il avoir peur de l'Amérique?* Paris: Seuil.

Bachelard, Gaston. 1984. *The New Scientific Spirit* (Arthur Goldhammer trans.). Boston: Beacon Press.

Baye-Salzmann, Pierre. 1992. "Negro Art, Its Inspiration and Contribution to [the] Occident." *La Revue du Monde noir, 1931–1932: Collection complète*, no. 1 à 6. Paris: Jean-Michel Place.

Bell, Clive. 1913. *Art.* New York: Frederick A. Stokes.

Bergson, Henri. 1910. *Time and Free Will: An Essay on the Immediate Data of Consciousness* (F. L. Pogson trans.). London: George Allen & Unwin.

———. 1944. *Creative Evolution* (Arthur Mitchell trans.). New York: Random House.

———. 1970. *Oeuvres*, 3rd edn. Paris: Presses Universitaires de France.

———. 1992. *The Creative Mind* (Mabelle L. Andison trans.). New York: Citadel Press.

Bernadac, Marie-Laure, and Paule du Bouchet. 1993. *Picasso: Master of the New Idea*. London: Harry N. Abrams.

Bernasconi, Robert (ed.). 2003. *Race and Racism in Continental Philosophy*. Bloomington, IN: Indiana University Press.

Bidima, Jean-Godefroy. 1997. *L'art négro-africain*. Paris: Presses Universitaires de France.

Césaire, Aimé. 1947. *Cahier d'un retour au pays natal*. Paris: Bordas. [Available in English as: *Notebook of a Return to the Native Land* (Clayton Eshleman and Annette Smith eds. and trans.) (Middletown, CT: Wesleyan University Press, 2001).]

———. 1955. *Discours sur le colonialisme*. Paris: Présence Africaine. [Available in English as: *Discourse on Colonialism* (Joan Pinkham trans.) (New York: Monthly Review Press, 1972).]

———. 1956. *Lettre à Maurice Thorez*. Paris: Présence Africaine. [Available in English as: "Letter to Maurice Thorez" (Chike Jeffers trans.). *Social Text* 28 (2010): 145–52).]

———. 2005. *Nègre je suis, nègre je resterai. Entretiens avec Françoise Vergès*. Paris: Albin Michel.

Chamoiseau, Patrick, and Raphael Confiant. 1999. *Lettres créoles. Tracées antillaises et continentales de la littérature. Haïti, Martinique, Guadeloupe, Guyane 1635–1975.* Paris: Gallimard.

——, and Jean Bernabé. 1993. *Éloge de la créolité/In Praise of Creoleness* (bilingual edition; M. B. Taleb-Khyar trans.). Paris: Gallimard.

Coulon, Paul, and Paule Brasseur (eds). 1988. *Liberman 1802–1852: Une pensée et une mystique missionnaires.* Paris: Le Cerf.

——. 2002. "Léopold Sédar Senghor, les spiritains et Libermann." *Mémoire spiritaine* 15: 103–34.

d'Arboussier, Gabriel. 1949. "Une dangereuse mystification: la théorie de la négritude." *La Nouvelle Critique, Revue du Parti Communiste Français,* June: 34–47.

Davy, Georges. 1971. *L'homme, le fait social et le fait politique.* Paris: La Haye/Ecole Pratique des Hautes Études/Mouton.

De Benoist, Alain. 1986. *Europe, Tiers monde, même combat.* Paris: R. Laffont.

De Benoist, Joseph Roger. 1988. *Léopold Sédar Senghor.* Paris: Beauchesne.

Desanti, Jean Toussaint. 2000. "Négritude au-delà" in Annick Thébia-Melsan and Gérard Lamoureux (eds.), *Aimé Césaire, pour regarder le siècle en face.* Paris: Maisonneuve & Larose.

Descartes, René, 1998. *Discourse on Method,* 3rd edn. (Donald A. Cress trans.). Indianapolis, IN: Hackett.

Diagne, Souleymane Bachir. 2001. *Islam et société ouverte: La fidélité et le mouvement dans la philosophie de Muhammad Iqbal.* Paris: Maisonneuve et Larose.

Diop, Birago. 1958. *Les nouveaux contes d'Amadou Koumba.* Paris: Présence Africaine.

Edwards, Brent Hayes, 2003. *The Practice of Diaspora: Literature, Translation, and the Rise of Black Internationalism.* Cambridge, MA: Harvard University Press.

Fanon, Frantz. 1991. *Black Skin White Masks* (Constance Farrington trans.). New York: Grove Press.

Fraser, Douglas. 1974. *African Art as Philosophy.* New York: Interbook.

Frobenius, Leo. 1936. *Histoire de la civilisation africaine*, 4th edn. (H. Back and D. Ermont trans. from German to French). Paris: Gallimard.

——. 1940. *Le Destin des Civilisations*. Paris: Gallimard.

——. 1973. *Leo Frobenius, 1873–1973*: *An Anthology* (Eike Haberland ed.). Wiesbaden: F. Steiner.

Guibert, Armand, and Nimrod. 2006. *Léopold Sédar Senghor*. Paris: Seghers.

Guillaume, Paul, and Thomas Munro. 1926. *Primitive Negro Sculpture*. New York: Harcourt, Brace and Company.

Husserl, Edmund. 1970. *The Crisis of European Sciences and Transcendental Phenomenology*. Evanston, IL: Northwestern University Press.

Hymans, Jacques Louis. 1971. *Léopold Sédar Senghor*: *An Intellectual Biography*, Edinburgh: Edinburgh University Press.

Iqbal, Muhammad. *The Secrets of the Self* (Reynold A. Nicholson trans.). Available at: http://www.sacred-texts.com/isl/iq/iq.txt (last accessed on 16 September 2011).

Irele, Abiola. 1990. *The African Experience in Literature and Ideology*. Bloomington and Indianapolis: Indiana University Press.

Jones, Donna V. 2010. *The Racial Discourses of Life Philosophy. Négritude, Vitalism, and Modernity*. New York: Columbia University Press.

Kagamé, Alexis. 1956. *La philosophie bantu-rwandaise de l'être*. Brussels: Academie Royale des sciences coloniales.

Keck, Frédéric. 2003. *Le problème de la mentalité primitive*: Lévy-Bruhl entre philosophie et anthropologie. PhD diss. Available at: www.univ-lille3.fr/theses/-keck-frederic/html/these.html (last accessed on 16 September 2011).

Kesteloot, Lilian. 1998. "L'après guerre, l'anthologie de Senghor et la préface de Sartre." *Ethiopiques, revue négro-africaine de littérature et de philosophie* 61. Available at: http://ethiopiques .refer.sn/spip.php?article1302 (last accessed on 16 September 2011).

Laburthe-Tolra, Philippe. 1998. *Critiques de la raison ethnologique*. Paris: Presses Universitaires de France.

Leiris, Michel. 1994. *Entretien sur l'art africain par Paul Lebeer.* Lausanne: La Bibliothèque des Arts.

Lévinas, Emmanuel. 1998. *Entre-nous: On Thinking-of-the-Other* (Michael B. Smith and Barbara Harshav trans). New York: Columbia University Press.

——. 2003. *Humanism of the Other* (Nidra Poller trans.). Urbana, IL: University of Illinois Press.

Lévy-Bruhl, Lucien. 1935. *Primitives and the Super-natural* (Lilian A. Clare trans.). New York: E.P. Dutton.

——. 1952. "A Letter to E. E. Evans-Pritchard" in *The British Journal of Sociology* 3 (June): 117–23.

——. 1975. *The Notebooks on Primitive Mentality* (Peter Rivière trans.). Oxford: Basil Blackwell.

——. 1985. *How Natives Think* (Lilian A. Clare trans.). Princeton, NJ: Princeton University Press.

Malraux, Andre. 1976. *Picasso's Mask* (June Guicharnaud trans.). New York: Holt, Rinehart and Wilson.

——. 1978. "Foreword" in *Masterpieces of Primitive Art.* New York: Alfred A. Knopf.

Maritain, Jacques. 1968. *Integral Humanism* (Joseph W. Evans trans.). New York: Charles Scribner's Sons.

Marx, Karl, and Friedrich Engels. 1972. *The Marx- Engels Reader,* 2nd edn. (Robert C. Tucker ed.) New York: W. W. Norton & Company.

Nancy, Jean-Luc. 2005. "Preface" in Mustapha Chérif, *L'islam, l'autre et la mondialisation.* Algiers: Anep.

Ndaw, Alassane. 1983. *La pensée africaine.* Dakar: Les Nouvelles Éditions Africaines.

Ngal, George. 1994. *Lire le Discours sur le colonialisme d'Aimé Césaire.* Paris: Présence Africaine.

Nietzsche, Friedrich. 1967. *The Birth of Tragedy and The Case of Wagner* (Walter Kaufmann trans.). New York: Vintage.

Nimrod. 2003. *Le tombeau de Léopold Sédar Senghor.* Paris: Le Temps qu'il fait.

Newton, Douglas. 1978. *Masterpieces of Primitive Art.* New York: Alfred A. Knopf.

New York Times. 2005. "DNA Tells Students They Aren't Who They Thought." 13 April.

Politzer, Georges. 1947. *Le bergsonisme, une mystification philosophique.* Paris: Les Editions Sociales.

Picon, Gaetan. 1957. *Panorama des idées contemporaines.* Paris: Gallimard.

Rimbaud, Arthur. 2001. *Collected Poems* (Martin Sorrell trans.). Oxford, UK: Oxford University Press.

Sartre, Jean-Paul. 1948. *The Emotions: Outline of a Theory* (Bernard Frechtman trans.). New York: Wisdom Library.

———. 1963a. *Black Orpheus* (S. W. Allen trans.). Paris: Présence Africaine.

———. 1963b. *Saint Genet, Actor and Martyr* (Bernard Frechtman trans.). New York: George Braziller.

———. 1992. *Being and Nothingness* (Hazel E. Barnes trans.). New York: Washington Square Press.

Schuhl, Pierre-Maxime. 1957. "Hommage à Lévy-Bruhl." *Revue Philosophique de la France et de l'Etranger* 4 (October–December): 398–403.

Sorel, Jacqueline. 1995. *Léopold Sédar Senghor, l'émotion et la raison.* Paris: Sépia.

Spivak, Gayatri Chakravorty. 1990. *The Postcolonial Critic: Interviews, Strategies, Dialogues* (Sarah Harasym ed.). New York: Routledge.

Teilhard de Chardin, Pierre. 1959. *The Phenomenon of Man* (Bernard Wall, trans.). New York: Harper Colophon.

———. 1969. *Human Energy* (J. M. Cohen trans.). London: Collins.

Tempels, Placide. 1959. *Bantu Philosophy* (Colin King trans.). Paris: Présence Africaine.

Tillot, Renée. 1979. *Le rythme dans la poésie de Léopold Sédar Senghor.* Dakar: Les Nouvelles Éditions Africaines.

Towa, Marcien. 1983. *Poésie de la négritude, approche structuraliste.* Sherbrooke: Naaman.

Vaillant, Janet. 1990. *Black, French, and African: A Life of Léopold Sédar Senghor.* Cambridge, MA: Harvard University Press.

Valéry, Paul. 1968. *The Collected Works of Paul Valéry, Volume 9: Masters and Friends* (Jackson Matthews ed., and Martin Turnell trans.). Princeton, NJ: Princeton University Press.

White, Edmund. 1993. *Genet: A Biography.* New York: Alfred A. Knopf.